The

HISTORY AND PRACTICE

of the

ART OF PHOTOGRAPHY

By Henry H. Snelling

with an introduction by
BEAUMONT NEWHALL

Morgan & Morgan, Inc., Publishers
Hastings-on-Hudson, N.Y.

The Fountain Press, London

Published in Collaboration with The George Eastman House
Rochester, New York

International Standard Book Number 0-87100-014-8
Library of Congress Catalog Card Number 73-119993
Printed in The United States of America

Introduction

*In the early days of photography in America, Daguerre's
original process was greatly modified. Cameras, plate
shields, buff sticks, vises, coating boxes and mercury
baths were redesigned. New techniques were introduced:
the silver-copper plates were enriched by electroplating
more silver upon them, and various chemical mixtures,
called "quickstuff" by the operators, were used to
increase the sensitivity of the iodized plates. Initiation
into the secrets of the trade was by personal instruction
and tuition fees were an important part of an estab-
lished daguerrean artist's income. There were no text-
books describing these American improvements to
Daguerre's invention process until Henry Hunt Snelling
wrote* The History and Practice of the Art of
Photography *in 1849, which we reproduce in exact
facsimile, including the binding, from an original first
edition in the George Eastman House collection.*

*Although the emphasis of the book is on the daguer-
reotype process, detailed instructions are given on the
paper negative process invented in England by Henry
Fox Talbot and improved by Sir John F. W. Herschel
and Robert Hunt.*

*Henry Hunt Snelling was born on November 8, 1817,
in Plattsburg, N.Y. where his father, Colonel Josiah
Snelling was stationed. Six weeks later Colonel Snelling
put the infant in a basket strapped to the front of his*

saddle, and began the long trek to his new post in Council Bluffs, Iowa. The family rode on horseback across the mountains to Pittsburgh, and then by keelboat down the Ohio River, up the Mississippi and Missouri to Council Bluffs. In 1822, Colonel Snelling was appointed Military Governor of the Northwest Territory, stationed at Fort St. Peters (now Fort Snelling) on the Minnesota River. Henry was sent east to a military academy in Georgetown, D. C.; on the death of his father in 1829 he moved to Detroit. After he had completed his schooling, he went into business.

Two events in 1837 shaped Snelling's future: he married Anna, the sister of George P. Putnam, a leading publisher, and he lost every cent he owned in a bank failure. For the next ten years he went from job to job, writing, editing, publishing, printing, with discouraging success. Then in 1847 he obtained a position with Edward Anthony, a pioneer daguerreotypist who had just opened business in New York manufacturing and selling cameras, plates, cases, chemicals and all the apparatus and supplies needed by daguerreotypists. Anthony's store at 308 Broadway was in the heart of photographic activity, and Snelling not only met the leading daguerreotypists, but worked with them. When Brady complained of having difficulty exposing plates in "the hot, yellow atmosphere" that even then invaded New York, Snelling experimented with blue glass which he cut to fit "the nozzle of a half tube." This pioneer

use of a filter enabled Frederick Catherwood to take
daguerreotypes in the jungles of Central America.
Snelling designed a new camera, an enlarger, and a
ventilated mercury bath, to lead the noxious fumes
safely away from the operating room. Though practical,
these inventions proved too costly.

A second edition of The Art of Photography
appeared in 1851, and a fourth in 1853, which included,
with separate pagination, a translation by Mrs. Snelling
of the French manual The Collodion Process in
Photography for the Production of Instantaneous
Proofs, by Alphonse de Brebisson.

In January, 1851, Snelling began to edit and publish
The Photographic Art Journal, a monthly maga-
zine containing news about the profession, technical
articles, often from foreign journals or books, and bio-
graphical sketches of leading daguerreotypists, together
with lithographic portraits of them. Originally octavo
in format, the magazine was increased to folio size and
its name changed to The Photographic and Fine
Art Journal in 1854. By then the collodion process
was displacing the daguerreotype and each issue
contained an original photograph.

Snelling published two further books: an illustrated
Dictionary of the Photographic Art (1854) and
A Guide to the Whole Art of Photography
(1858). His health broke down, from overwork, and
he left Albany in 1858 to form a printing office, but

after two years it failed due, he said, to the infidelity of his partner. He then entered government service as a tax collector. For a while he was a farmer in Newburgh, N.Y. Then he edited and published The Register of Cornwall, (N.Y.). In 1887 he became almost completely blind.

The editor and publisher of the St. Louis and Canadian Photographer *rescued him from the poor house and issued an appeal in 1893 for contributions to a fund "to secure a place for this aged toiler in the field of photography in the Home for Aged People in St. Louis, a haven of rest wherein he can end his days in peace and quiet, free from care and worry." He died in 1897.*

Beaumont Newhall
2 March 1970

THE

HISTORY AND PRACTICE

OF THE

ART OF PHOTOGRAPHY;

OR THE

PRODUCTION OF PICTURES THROUGH THE AGENCY OF LIGHT.

CONTAINING

ALL THE INSTRUCTIONS NECESSARY FOR THE COMPLETE PRAC-
TICE OF THE DAGUERREAN AND PHOTOGENIC ART,
BOTH ON METALIC PLATES AND ON PAPER.

BY HENRY H. SNELLING.

———————

ILLUSTRATED WITH WOOD CUTS.

———————

New York:
PUBLISHED BY G. P. PUTNAM,
155 Broadway.

1849.

New York:
PRINTED BY BUSTEED & McCOY,
163 Fulton Street.

PREFACE.

————◄●►————

THE object of this little work is to fill a void much complained of by Daguerreotypists—particularly young beginers.

The author has waited a long time in hopes that some more able pen would be devoted to the subject, but the wants of the numerous, and constantly increasing, class, just mentioned, induces him to wait no longer.

All the English works on the subject—particularly on the practical application, of Photogenic drawing—are deficient in many minute details, which are essential to a complete understanding of the art. Many of their methods of operating are entirely different from, and much inferior to, those practised in the United States : their apparatus, also, cannot compare with ours for completeness, utility or simplicity.

I shall, therefore, confine myself principally—so far as Photogenic drawing upon metalic plates is concerned—to the methods practised by the most celebrated and experienced operators, drawing upon French and English authority only

in cases where I find it essential to the purpose for which I design my work, namely: furnishing a compléte system of Photography; such an one as will enable any gentleman, or lady, who may wish to practise the art, for profit or amusement, to do so without the trouble and expense of seeking instruction from professors, which in many cases within my own knowledge has prevented persons from embracing the profession.

To English authors I am principally indebted for that portion of my work relating to Photogenic drawing on paper. To them we owe nearly all the most important improvements in that branch of the art. Besides, it has been but seldom attempted in the United States, and then without any decided success. Of these attempts I shall speak further in the Historical portion of this volume.

Every thing essential, therefore, to a complete knowledge of the whole art, comprising all the most recent discoveries and improvements down to the day of publication will be found herein laid down.

INTRODUCTION.

New York, January 27, 1849.

E. ANTHONY, ESQ.

Dear Sir,—In submiting the accompanying "History and Practice of Photography to your perusal, and for your approbation, I do so with the utmost confidence in your ability as a practical man, long engaged in the science of which it treats, as well as your knowledge of the sciences generally, as well as your regard for candor. To you, therefore, I leave the decision whether or no I have accomplished my purpose, and produced a work which may not only be of practical benefit to the Daguerrean artist, but of general interest to the reading public, and your decision will influence me in offering it for, or withholding it from, publication.

If it meets your approbation, I would most respectfully ask permission to dedicate it to you, subscribing myself,

With esteem,

Ever truly yours,

HENRY H. SNELLING.

———

New York, February 1st, 1849.

MR. H. H. SNELLING.

Dear Sir—Your note of January 27th, requesting permission to dedicate to me your "History and Practice of Photography," I esteem a high compliment, particularly since I have read the manuscript of your work.

Such a treatise has long been needed, and the manner in

which you have handled the subject will make the book as interesting to the reading public as it is valuable to the Daguerrean artist, or the amateur dabbler in Photography. I have read nearly all of the many works upon this art that have emanated from the London and Paris presses, and I think the reader will find in yours the pith of them all, with much practical and useful information that I do not remem. ber to have seen communicated elsewhere.

There is much in it to arouse the reflective and inventive faculties of our Daguerreotypists. They have heretofore stumbled along with very little knowledge of the true theory of their art, and yet the quality of their productions is far in advance of those of the French and English artists, most of whose establishments I have had the pleasure of visiting I feel therefore, that when a sufficient amount of theoretic know'edge shall have been added to this practical skill on the part of our operators, and when they shall have been made fully acquainted with what has been attained or attempted by others, a still greater advance in the art will be manifested.

A GOOD Daguerreotypist is by no means a mere machine following a certain set of fixed rules. Success in this art requires personal skill and artistic taste to a much greater degree than the unthinking public generally imagine; in fact more than is imagined by nine-tenths of the Daguerreotypists themselves. And we see as a natural result, that while the business numbers its thousands of votaries, but few rise to any degree of eminence. It is because they look upon their business as a mere mechanical operation, and having no aim or pride beyond the earning of their daily bread, they calculate what will be a fair per centage on the cost of their plate, case, and chemicals, leaving MIND, which is as much CAPITAL as anything else (where it is exercised,) entirely out of the question.

The art of taking photographs on PAPER, of which your work treats at considerable length, has as yet attracted but

little attention in this country, though destined, as I fully believe, to attain an importance far superior to that to which the Daguerreotype has risen.

The American mind needs a waking up upon the subject, and I think your book will give a powerful impulse in this direction. In Germany a high degree of perfection has been reached, and I hope your countrymen will not be slow to follow.

Your interesting account of the experiments of Mr. Wattles was entirely new to me, and is another among the many evidences that when the age is fully ripe for any great discovery, it is rare that it does not occur to more than a single mind.

Trusting that your work will meet with the encouragement which your trouble in preparing it deserves, and with gratitude for the undeserved compliment paid to me in its dedication,

> I remain, very sincerely,
>> Your friend and well wisher,
>>> E. ANTHONY.

PHOTOGRAPHY.

CHAP. I.

As in all cases of great and valuable inventions in sci-
ence and art the English lay claim to the honor of having
first discovered that of Photogenic drawing. But we
shall see in the progress of this history, that like many
other assumptions of their authors, priority in this is no
more due them, then the invention of steamboats, or the
cotton gin.

This claim is founded upon the fact that in 1802 Mr.
Wedgwood recorded an experiment in the Journal of the
Royal Institution of the following nature.

" A piece of paper, or other convenient material, was
placed upon a frame and sponged over with a solution of
nitrate of silver ; it was then placed behind a painting
on glass and the light traversing the painting produced a
kind of copy upon the prepared paper, those parts in
which the rays were least intercepted being of the darkest
hues. Here, however, terminated the experiment ; for
although both Mr. Wedgwood and Sir Humphry Davey
experimented carefully, for the purpose of endeavoring

to fix the drawings thus obtained, yet the object could not be accomplished, and the whole ended in failure."

This, by their own showing, was the earliest attempt of the English savans. But this much of the principle was known to the Alchemists at an early date—although practically produced in another way—as the following experiment, to be found in old books, amply proves.

"Dissolve chalk in aquafortis to the consistence of milk, and add to it a strong solution of silver ; keep this liquor in a glass bottle well stopped ; then cutting out from a piece of paper the letters you would have appear, paste it on the decanter, and lay it in the sun's rays in such a manner that the rays may pass through the spaces cut out of the paper and fall on the surface of the liquor ; the part of the glass through which the rays pass will be turned black, while that under the paper remains white ; but particular care must be observed that the bottle be not moved during the operation."

Had not the alchemists been so intent upon the desire to discover the far famed philosopher's stone, as to make them unmindful of the accidental dawnings of more valuable discoveries, this little experiment in chemistry might have induced them to prosecute a more thorough search into the principle, and Photogenic art would not now, as it is, be a new one.

It is even asserted that the Jugglers of India were for many ages in possession of a secret by which they were enabled, in a brief space, to copy the likeness of any in-dividual by the action of light. This fact, if fact it be, may account for the celebrated magic mirrors said to be possessed by these jugglers, and probable cause of their power over the people.

However, as early as 1556 the fact was established that a combination of chloride and silver. called, from its appearance, horn silver, was blackened by the sun's rays ; and in the latter part of the last century Mrs. Fulhame published an experiment by which a change of color was effected in the chloride of gold by the agency of light ; and gave it as her opinion that words might be written in this way. These incidents are considered as the first steps towards the discovery of the Photogenic art.

Mr. Wedgwood's experiments can scarcely be said to be any improvement on them since he failed to bring them to practical usefulness, and his countrymen will have to be satisfied with awarding the honor of its complete adaptation to practical purposes, to MM. Niepce and Daguerre of France, and to Professors Draper, and Morse of New-York.

These gentlemen—MM. Niepce and Daguerre—pursued the subject simultaneously, without either, however being aware of the experiments of his colleague in science. For several years, each pursued his researches individually until chance made them acquainted, when they entered into co-partnership, and conjointly brought the art almost to perfection.

M. Niepce presented his first paper on the subject to the Royal Society in 1827, naming his discovery Heliography. What led him to the study of the principles of the art I have no means, at present, of knowing, but it was probably owing to the facts recorded by the Alchemists, Mrs. Fulhame and others, already mentioned. But M. Daguerre, who is a celebrated dioramic painter, being desirous of employing some of the singularly changeable salts of silver to produce a peculiar class of effects in his

paintings, was led to pursue an investigation which resulted in the discovery of the Daguerreotype, or Photogenic drawing on plates of copper coated with silver.

To this gentleman—to his liberality—are we Americans indebted for the free use of his invention; and the large and increasing class of Daguerrean artists of this country should hold him in the most profound respect for it. He was not willing that it should be confined to a few individuals who might monopolise the benefits to be derived from its practice, and shut out all chance of improvement. Like a true, noble hearted French gentleman he desired that his invention should spread freely throughout the whole world. With these views he opened negociations with the French government which were concluded most favorably to both the inventors, and France has the " glory of endowing the whole world of science and art with one of the most surprising discoveries that honor the land."

Notwithstanding this, it has been patented in England and the result is what might have been expected: English pictures are far below the standard of excellence of those taken by American artists. I have seen some medium portraits, for which a guinea each had been paid, and taken too, by a celebrated artist, that our poorest Daguerreotypists would be ashamed to show to a second person, much less suffer to leave their rooms.

CALOTYPE, the name given to one of the methods of Photogenic drawing on paper, discovered, and perfected by Mr. Fox Talbot of England, is precisely in the same predicament, not only in that country but in the United States, Mr. Talbot being patentee in both. He is a man of some wealth, I believe, but he demands so high a price

for a single right in this country, that none can be found who have the temerity to purchase.

The execution of his pictures is also inferior to those taken by the German artists, and I would remark *en passant*, that the Messrs. Mead exhibited at the last fair of the American Institute, (of 1848,) four Calotypes, which one of the firm brought from Germany last Spring, that for beauty, depth of tone and excellence of execution surpass the finest steel engraving.

When Mr. Talbot's patent for the United States expires and our ingenious Yankee boys have the opportunity, I have not the slightest doubt of the Calotype, in their hands, entirely superceding the Daguerreotype.

Let them, therefore, study the principles of the art as laid down in this little work, experiment, practice and perfect themselves in it, and when that time does arrive be prepared to produce that degree of excellence in Calotype they have already obtained in Daguerreotype.

It is to Professor Samuel F. B. Morse, the distinguished inventor of the Magnetic Telegraph, of New York, that we are indebted for the application of Photography, to portrait taking. He was in Paris, for the purpose of presenting to the scientific world his Electro-Magnetic Telegraph, at the time, (1838,) M. Daguerre announced his splendid discovery, and its astounding results having an important bearing on the arts of design arrested his attention. In his letter to me on the subject, the Professor gives the following interesting facts.

" The process was a secret, and negociations were then in progress, for the disclosure of it to the public between the French government and the distinguished discoverer. M. Daguerre had shown his results to the king, and to a few only of the distinguished savans, and by the advice

of M. Arago, had determined to wait the action of the
French Chambers, before showing them to any other per-
sons. I was exceedingly desirous of seeing them, but
knew not how to approach M. Daguerre who was a
stranger to me. On mentioning my desire to Robert
Walsh, Esq., our worthy Consul, he said to me ; 'state
that you are an American, the inventor of the Telegraph,
request to see them, and invite him in turn to see the Te-
legraph, and I know enough of the urbanity and liberal
feelings of the French, to insure you an invitation.' I
was successfull in my application, and with a young
friend, since deceased, the promising son of Edward De-
levan, Esq., I passed a most delightful hour with M. Da-
guerre, and his enchanting sun-pictures. My letter con-
taining an account of this visit, and these pictures, was
the first announcement in this country of this splendid
discovery."

 " I may here add the singular sequel to this visit. On
the succeeding day M. Daguerre paid me a visit to see
the Telegraph and witness its operations. He seemed
much gratified and remained with me perhaps two hours ;
two melancholy hours to him, as they afterwards proved ;
or while he was with me, his buildings, including his
diorama, his studio, his laboratory, with all the beauti-
ful pictures I had seen the day before, were consumed
by fire. Fortunately for mankind, matter only was con-
sumed, the soul and mind of the genius, and the process
were still in existence."

 On his return home, Professor Morse waited with im-
patience for the revelation of M. Daguerre's process,
and no sooner was it published than he procured a copy
of the work containing it, and at once commenced taking
Daguerreotype pictures. At first his object was solely

to furnish his studio with studies from nature; but his experiments led him into a belief of the practicability of procuring portraits by the process, and he was undoubtedly the first whose attempts were attended with success. Thinking, at that time, that it was necessary to place the sitters in a very strong light, they were all taken with their eyes closed.

Others were experimenting at the same time, among them Mr. Wolcott and Prof. Draper, and Mr. Morse, with his acustomed modesty, thinks that it would be difficult to say to whom is due the credit of the first Daguerreotype portrait. At all events, so far as my knowledge serves me, Professor Morse deserves the laurel wreath, as from him originated the first of our inumerable class of Daguerreotypists; and many of his pupils have carried the manipulation to very great perfection. In connection with this matter I will give the concluding paragraph of a private letter from the Professor to me; He says.

" If mine were the first, other experimenters soon made better results, and if there are any who dispute that I was first, I shall have no argument with them ; for I was not so anxious to be the *first* to produce the result, as to produce it in any way. I esteem it but the natural carrying out of the wonderful discovery, and that the credit was after all due to Daguerre. I lay no claim to any improvements. "

Since I commenced the compilation of this work, I have had the pleasure of making the acquaintance of an American gentleman—James M. Wattles Esq.—who as early as 1828—and it will be seen, by what I have already stated, that this is about the same date of M. Niepce's

discovery—had his attention attracted to the subject of Photography, or as he termed it " Solar picture drawing," while taking landscape views by means of the camera-obscura. When we reflect upon all the circumstances connected with his experiments, the great disadvantages under which he labored, and his extreme youthfullness, we cannot but feel a national pride—yet wonder —that a mere yankee boy, surrounded by the deepest forests, hundred of miles from the populous portion of our country, without the necessary materials, or resources for procuring them, should by the force of his natural genius make a discovery, and put it in practical use, to accomplish which, the most learned philosophers of Europe, with every requisite apparatus, and a profound knowledge of chemistry—spent years of toil to accomplish. How much more latent talent may now be slumbering from the very same cause which kept Mr. Wattles from publicly revealing his discoveries, viz ; want of encouragement— ridicule !

At the time when the idea of taking pictures permanently on paper by means of the camera-obscura first occurred to him, he was but sixteen years of age, and under the instructions of Mr. Charles Le Seuer, (a talented artist from Paris) at the New Harmony school, Indiana. Drawing and painting being the natural bent of his mind, he was frequently employed by the professors to make landscape sketches in the manner mentioned. The beauty of the image of these landscapes produced on the paper in the camera-obscura, caused him to pause and admire them with all the ardor of a young artist, and wish that by some means, he could fix them there in all their beauty. From wishing he brought himself to think that it was not only possible but actually capable of accomplish-

ment, and from thinking it could, he resolved it should be done.

He was, however, wholly ignorant of even the first principles of chemistry, and natural philosophy, and all the knowledge he was enabled to obtain from his teachers was of very little service to him. To add to this, whenever he mentioned his hopes to his parents, they laughed at him, and bade him attend to his studies and let such moonshine thoughts alone—still he persevered, though secretly, and he met with the succes his peseverance deserved.

For the truth of his statement, Mr. Wattles refers to some of our most respectable citizens residing at the west, and I am in hopes that I shall be enabled to receive in time for this publication, a confirmation from one or more of these gentlemen. Be that as it may, I feel confident in the integrity of Mr. Wattles, and can give his statement to the world without a doubt of its truth.

The following sketch of his experiments and their results will, undoubtedly, be interesting to every American reader and although some of the profound philosophers of Europe may smile at his method of proceeding, it will in some measure show the innate genius of American minds, and prove that we are not far behind our trans-atlantic brethren in the arts and sciences.

Mr. Wattles says : "In my first efforts to effect the desired object, they were feeble indeed, and owing to my limited knowledge of chemistry—wholly acquired by questioning my teachers—I met with repeated failures ; but following them up with a determined spirit, I at last produced, what I thought very fair samples—but to proceed to my experiments."

" I first dipped a quarter sheet of thin white writing

paper in a weak solution of caustic (as I then called it) and dried it in an empty box, to keep it in the dark; when dry, I placed it in the camera and watched it with great patience for nearly half an hour, without producing any visible result; evidently from the solution being to weak. I then soaked the same piece of paper in a solution of common potash, and then again in caustic water a little stronger than the first, and when dry placed it in the camera. In about forty-five minutes I plainly percieved the effect, in the gradual darkening of various parts of the view, which was the old stone fort in the rear of the school garden, with the trees, fence, &c. I then became convinced of the practicability of producing beautiful solar pictures in this way; but, alas! my picture vanished and with it, all—no not *all*—my hopes. With renewed determination I began again by studying the nature of the preparation, and came to the conclusion, that if I could destroy the part not acted upon by the light without in juring that which was so acted upon, I could save my pictures. I then made a strong solution of sal. soda I had in the house, and soaked my paper in it, and then washed it off in hot water, which perfectly fixed the view upon the paper. This paper was very poor with thick spots, more absorbent than other parts, and consequently made dark shades in the picture where they should not have been; but it was enough to convince me that I had succeeded, and that at some future time, when I had the means and a more extensive knowledge of chemistry, I could apply myself to it again. I have done so since, at various times, with perfect success; but in every instance laboring under adverse circumstances."

I have very recently learned, that, under the present patent laws of the United States, every foreign patentee

is required to put his invention, or discovery, into prac-
tical use within eighteen months after taking out his
papers, or otherwise forfeit his patent. With regard to
Mr. Talbot's Calotype patent, this time has nearly, if not
quite expired, and my countrymen are now at perfect li-
berty to appropriate the art if they feel disposed. From
the statement of Mr. Wattles, it will be perceived that
this can be done without dishonor, as in the first instance
Mr. Talbot had no positive right to his patent.

Photography; or sun-painting is divided, according to
the methods adopted for producing pictures, into

DAGUERREOTYPE,	CHROMATYPE,
CALOTYPE,	ENERGIATYPE,
CHRYSOTYPE,	ANTHOTYPE and
CYANOTYPE,	AMPHITYPE.

CHAP. II.

THE THEORY ON LIGHT.—THE PHOTOGRAPHIC PRINCIPLE

SOME philosophers contend that to the existence of light alone we owe the beautiful effects produced by the Photogenic art, while others give sufficient reasons for doubting the correctness of the assumption. That the results are effected by a principle associated with light and not by the luminous principle itself, is the most probable conclusion. The importance of a knowledge of this fact becomes most essential in practice, as will presently be seen. To this principle Mr. Hunt gives the name of ENERGIA.

THE NATURE of Light is not wholly known, but it is generally believed to be matter, as in its motions it obeys the laws regulating matter. So closely is it connected with heat and electricity that there can be little doubt of their all being but different modifications of the same substance. I will not, however, enter into a statement of the various theories of Philosophers on this head, but content myself with that of Sir Isaac Newton ; who supposed rays of light to consist of minute particles of matter, which are constantly emanating from luminous bodies and cause vision, as odoriferous particles, proceeding from certain bodies, cause smelling.

The *effects* of light upon *other bodies*, and how light is effectèd by *them*, involve some of the most important principles, which if properly understood by Daguerreotypists would enable them to improve and correct many of the practical operations in their art. These effects we shall exhibit in this and the following chapters. Before we enter on this subject it will be necessary to become familiar with the

DEFINITIONS of some of the terms used in the science of optics.

Luminous bodies are of two kinds; those which shine by their *own* light, and those which shine by *reflected* light.

Transparent bodies are such as permit rays of light to pass through them.

Translucent bodies permit light to pass faintly, but without representing the figure of objects seen through them.

Opaque bodies permit no light to pass through them, but reflect light.

A *ray* is a line of light.

A *beam* is a collection of parallel rays.

A *pencil* is a collection of converging, or diverging rays.

A *medium* is any space through which light passes.

Incident rays are those which fall upon the surface of a body.

Reflected rays are those which are thrown off from a body.

Parallel rays are such as proceed equally distant from each other through their whole course.

Converging rays are such as approach and tend to unite at any one point, as at *b. fig.* 3.

Diverging rays are those which continue to recede from each other, as at *e. Fig.* 3.

A *Focus* is that point at which converging rays meet.

MOTION OF LIGHT—Rays of light are thrown off from luminous bodies in every direction, but always in straight lines, which cross each other at every point; but the particles of which each ray consists are so minute that the rays do not appear to be impeded by each other. A ray of light passing through an aperture into a dark room, proceeds in a straight line ; a fact of which any one may be convinced by going into a darkened room and admiting light only through a small aperture.

Light also moves with great velocity, but becomes fainter as it recedes from the source from which it eminates ; in other words, diverging rays of light diminish in intensity as the square of the distance increases. For instance; let *a* fig. 1, represent the luminous body from

FIG. 1.

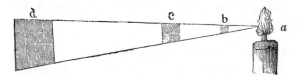

which light proceeds, and suppose three square boards, *b. c. d.* severally one, four and sixteen square inches in size be placed ; *b* one foot, *c* two feet, and *d* four feet from *a*, it will be perceived that the smallest board *b* will throw *c* into shadow ; that is, obstruct all rays of light that would otherwise fall on *c*, and if *b* were removed *c* would in like manner hide the light from *d*—Now, if *b* recieve as much light as would fall on *c* whose surface is four times as large, the light must be four times as pow-

erful, and sixteen times as powerful as that which would fall on the second and third boards, because the same quantity of light is diffused over a space four and sixteen times greater. These same rays may be collected and their intensity again increased.

Rays of light are *reflected* from one surface to another ; *Refracted*, or bent, as they pass from the surface of one transparent medium to another ; and *Inflected*, or turned from their course, by the attraction of opaque bodies. From the first we derive the principles on which mirrors are constructed ; to the second we are indebted for the power of the *lenses*, and the blessings of sight,—for the light acts upon the *retina* of the eye in the same manner as on the lens of a camera. The latter has no important bearing upon our subject.

When a ray of light falls perpendicularly upon an opaque body, it is reflected back in the same line in which it proceeds ; in this case the *reflected* ray returns in the same path the *incident* ray traversed ; but when a ray falls obliquely, it is reflected obliquely, that is, it is thrown off in an opposite direction, and as far from the perpendicular as was the incident ray, as shown at *Fig.* 2 ; *a* representing the incident ray and *b* the reflected.

The point, or angle *c* made by the incident ray, at the surface of the reflector *e f*, with a line *c d*, perpendicular to that surface, is called the *angle of incidence ,* while the angle formed by the reflected ray *b* and the perpendicular line *d* is

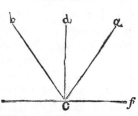

FIG. 2.

called the *angle of reflection,* and these angles are always equal.

It is by this reflection of light that objects are made visible; but unless light falls directly upon the eye they are invisible, and are not sensibly felt until after a certain series of operations upon the various coverings and humors of the eye. Smooth and polished surfaces reflect light most powerfully, and send to the eye the images of the objects from which the light proceeded before reflection. Glass, which is transparent—*transmitting light*—would be of no use to us as a mirror, were it not first coated on one side with a metalic amalgam, which interrupts the rays in their passage from the glass into the air, and throws them either directly in the incident line, or in an oblique direction. The reason why trees, rocks and animals are not all mirrors, reflecting other forms instead of their own, is, that their surfaces are uneven, and rays of light reflected from an uneven surface are diffused in all directions.

Parallel rays falling obliquely upon a plane mirror are reflected parallel; converging rays, with the same degree of convergence ; and diverging rays equally divergent.

Stand before a mirror and your image is formed therein, and appears to be as far behind the glass as you are before it, making the angle of reflection equal to that of incidence, as before stated. The incident ray and the reflected ray form, together, what is called the passage of reflection, and this will therefore make the actual distance of an image to appear as far again from the eye as it really is. Any object which reflects light is called a radiant. The point behind a reflecting surface, from which they appear to diverge, is called the virtual focus.

Rays of light being reflected at the same angle at which they fall upon a mirror, two persons can stand in such a position that each can see the image of the other without seeing his own. Again ; you may see your

whole figure in a mirror half your length, but if you stand before one a few inches shorter the whole cannot be reflected, as the incident ray which passes from your feet into the mirror in the former case, will in the latter fall under it. Images are always reversed in mirrors.

Convex mirrors reflect light from a rounded surface and disperse the rays in every direction, causing parallel rays to diverge, diverging rays to diverge more, and converging rays to converge less—They represent objects smaller than they really are—because the angle formed by the reflected ray is rendered more acute by a convex than by a plane surface, and it is the diminishing of the visual angle, by causing rays of light to be farther extended before they meet in a point, which produces the image of convex mirrors. The greater the convexity of a mirror, the more will the images of the objects be diminished, and the nearer will they appear to the surface. These mirrors furnish science with many curious and pleasing facts.

Concave mirrors are the reverse of convex ; the latter being rounded outwards, the former hollowed inwards— they render rays of light more converging—collect rays instead of dispersing them, and magnify objects while the convex diminishes them.

Rays of light may be collected in the focus of a mirror to such intensity as to melt metals. The ordinary burning glass is an illustration of this fact ; although the rays of light are refracted, or passed through the glass and concentrated into a focus beneath.

When incident rays are parallel, the reflected rays converge to a focus, but when the incident rays proceed from a focus, or are divergent, they are reflected parallel. It is only when an object is nearer to a concave mirror than its

centre of concavity, that its image is magnified ; for when the object is farther from the mirror, this centre will appear less than the object, and in an inverted position.

The centre of concavity in a concave mirror, is an imaginary point placed in the centre of a circle formed by continuing the boundary of the concavity of the mirror from any one point of the edge to another parallel to and beneath it.

REFRACTION OF LIGHT:— I now pass to the consideration of the passage of light through bodies.

A ray of light falling perpendicularly through the air upon a surface of glass or water passes on in a straight line through the body; but if it, in passing from one medium to another of different density, fall obliquely, it is bent from its direct course and recedes from it, either towards the right or left, and this bending is called refraction; (see fig. 3, b.) If a ray of light passes from a rarer into a denser medium it is refracted towards a perpendicular in that medium ; but if it passes from a denser into rarer it is bent further from a perpendicular in that medium. Owing to this bending of the rays of light the angles of refraction and incidence are never equal.

Transparent bodies differ in their power of bending light—as a general rule, the refractive power is proportioned to the density—but the chemical constitution of bodies as well as their density, is found to effect their refracting power. Inflamable bodies possess this power to a great degree.

The sines of the angle of incidence and refraction (that is, the perpendicular drawn from the extremity of an arc to the diameter of a circle,) are always in the same ratio ; viz : from air into water, the sine of the angle of refraction is nearly as four to three, whatever be the position of

the ray with respect to the refracting surface. From air into sulphur, the sine of the angle of refraction is as two to one—therefore the rays of light cannot be refracted whenever the sine of the angle of refraction becomes equal to the radius * of a circle, and light falling very obliquely upon a transparent medium ceases to be refracted; this is termed *total reflection.*

Since the brightness of a reflected image depends upon the quantity of light, it is quite evident that those images which arise from total reflection are by far the most vivid, as in ordinary cases of reflection a portion of light is absorbed.

I should be pleased to enter more fully into this branch of the science of optics, but the bounds to which I am necessarily limited in a work of this kind will not admit of it. In the next chapter, however, I shall give a synopsis of Mr. Hunt's treatise on the " Influence of the Solar Rays on Compound Bodies, with especial reference to their Photographic application "—A work which should be in the hands of every Daguerreotypist, and which I hope soon to see republished in this country. I will conclude this chapter with a brief statement of the principles upon which the Photographic art is founded.

SOLAR and Steller light contains three kinds of rays, viz:

1. *Colorific*, or rays of color.

2. Calorific, or rays of heat.

3. Chemical rays, or those which produce chemical effects.

On the first and third the photographic principle depends. In explaining this principle the accompanying wood cuts, (*figs*. 3 and 4) will render it more intelligible.

* The RADIUS of a circle is a straight line passing from the centre to the circumference.

If a pencil of the sun's rays fall upon a prism, it is bent in passing through the transparent medium ; and some rays being more refracted than others, we procure an elongated image of the luminous beam, exhibiting three distinct colors, red, yellow and blue, which are to be regarded as primitives—and from their interblending, seven, as recorded by Newton, and shown in the accompanying wood cut. These rays being absorbed, or reflected differently by various bodies, give to nature the charm of color. Thus to the eye is given the pleasure we derive in looking upon the green fields and forests, the enumerable varieties of flowers, the glowing ruby, jasper, topaz, amethist, and emerald, the brilliant diamond, and all the rich and varied hues of nature, both animate and inanimate.

FIG. 3.

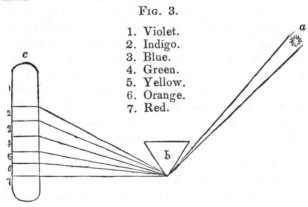

1. Violet.
2. Indigo.
3. Blue.
4. Green.
5. Yellow.
6. Orange.
7. Red.

Now, if we allow this prismatic spectrum (*b. fig.* 3.) to fall upon any surface (as at *c.*) prepared with a sensitive photographic compound, we shall find that the chemical effect produced bears no relation to the intensity of the *light* of any particular colored ray, but that, on the

contrary, it is dispersed over the largest portion of the
spectrum, being most energetic in the least luminous
rays, and ever active over an extensive space, where no
traces of light can be detected. *Fig.* 4, will give the
student a better idea of this principle. It is a copy of
the kind of impression which the spectrum, spoken of,
would make on a piece of paper covered with a very
sensitive photographic preparation. The *white* space *a.*
corresponds with the most luminous, or yellow ray,
(5, fig. 3) over limits of which all chemical change is
prevented. A similar ac-

FIG. 4.

tion is also produced by
the lower end of the red
ray *c*; but in the upper
portion, however we find
a decided change (as at *d*).
The most active chemical
change, you will percieve,
is produced by the rays a-
bove the yellow *a*; viz.
4, 3, 2 and 1 (as at *b*) the
green (4) being the least
active, and the blue (3)
and violet (1) rays the
most so, the action still
continuing far beyond the
point *b* which is the end
of the luminous image.

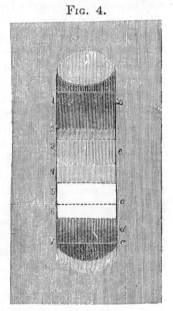

Suppose we wish to copy
by the Daguerreotype, or
Calotype process, any objects highly colored—blue, red
and yellow, for instance predominating—the last of course
reflects the most light, the blue the least ; but the rays

from the blue surface will make the most intense impression, whilst the red radiations ate working very slowly, and the yellow remains entirely inactive. This accounts for the difficulty experienced in copying bright green foliage, or warmly colored portraits; a large portion of the yellow and red rays entering into the composition of both—and the imperfections of a Daguerreotype portrait of a person with a freckled face depends upon the same cause.

A yellow, hazy atmosphere, even when the light is very bright, will effectually prevent any *good* photographic result—and in the height of summer, with the most sensative process, it not unfrequently happens that the most anoying failures arise from this agency of a yellow medium. A building painted of a yellow color, which may reflect the sun's rays directly into the operator's room will have the same effect. Daguerreotypists, being ignorant of these facts, are very apt to charge their want of success to the plates, or chemicals, or any thing but the real cause; and it would be well to bear these facts constantly in mind and as far as possible avoid them. This, may be accomplished, in a measure, by a choice of location or by having the glass of your windows tinged with blue ; or a screen of thin blue paper may be interposed between the light and sitter. In selecting subjects, all striking contrasts in color should be avoided, and sitters for portraits should be cautioned not to wear anything that may produce the effect spoken of—dark dresses always being the best.

The action of light both combines and decomposes bodies. For instance, chlorine and hydrogen will remain in a glass vessel without alteration if kept in the dark ; but if exposed to the rays of the sun, they imme-

diately enter into combination, and produce hydrochloric acid. On the other hand, if colorless nitric acid be exposed to the sun, it becomes yellow, then changes to red, and oxygen is liberated by the partial decomposition effected by the solar rays.

Of the organic substances none are more readily acted upon by light than the various combinations of silver. Of these some are more, and others less sensitive. If Chloride of silver, which is a white precipitate formed by adding chloride of sodium (common salt) to a solution of nitrate of silver, be exposed to diffused light, it speedily assumes a violet tint, and ultimately becomes nearly black. With iodide of silver, bromide of silver, ammonio-nitrate of silver, and other salts of this metal, the result will be much the same.

Some bodies, which under the influence of light, undergo chemical changes, have the power of restoring themselves to their original condition in the dark. This is more remarkably displayed in the iodide of platinum, which readily recieves a photogenic image by darkening over the exposed surfaces, but speedily loses it by bleaching in the dark. The ioduret of Daguerre's plate, and some other iodides, exhibit the same peculiarity—This leads us to the striking fact, that bodies which have undergone a change of estate under the influence of daylight have some latent power by which they can renovate themselves. Possibly the hours of night are as necessary to inanimate nature as they are to the animate. During the day, an excitement which we do not heed, unless in a state of disease, is maintained by the influence of light; and the hours of repose, during which the equilibrium is restored, are absolutely necessary to the continuance of health.

Instead of a few chemical compounds of gold and silver, which at first were alone supposed to be photographic, we are now aware that copper, platinum, lead, nikel, and indeed, probably all the elements, are equally liably to change under the sun's influence. This fact may be of benefit to engravers, for if steel can be made to take photographic impressions, the more laborious process of etching may be dispensed with. In fact, in the latter part of this work, a proeess is described for etching and taking printed impressions from Daguerreotype plates. As yet this process has produced no decided beneficial results—but future experiments may accomplish some practical discovery of intrinsic value to the art of engraving.

A very simple experiment will prove how essential light is to the coloring of the various species comprising the vegetable and animal kingdoms. If we transplant any shrub from the light of day into a dark cellar, we will soon see it lose its bright green color, and become perfectly white.

Another effect of light is that it appears to impart to bodies some power by which they more readily enter into chemical combination with others. We have already said that chlorine and hydrogen, if kept in the dark, will remain unaltered ; but if the chlorine alone be previously exposed to the sun, the chlorine thus solarised will unite with the hydrogen in the dark. Sulphate of iron will throw down gold or silver from their solutions slowly in the dark ; but if either solution be first exposed to sunshine, and the mixture be then made, in the dark, the precipitation takes place instantly. Here is again, evidence of either an absorption of some material agent from the sunbeam, or an alteration in the chemical constitution of the body. It was from understanding these principles and

applying them that philosophers were enabled to produce the Calotype, Daguerreotype, &c. For the effects and action of light on the camera, see Chapter V.

Some advances have been made towards producing Photographic impressions in color—the impossibility of which, some of our best and oldest artists have most pertinaciously maintained. The colored image of the spectrum has been most faithfully copied, ray for ray, on paper spread with the juice of the *Cochorus Japonica*, (a species of plant) and the fluoride of silver ; and on silver plate covered with a thin film of chloride. The day may be still remote when this much to be desired decideratum shall be accomplished in portrait taking ; but I am led to hope that future experiments may master the secret which now causes it to be looked upon, by many, as an impossibility.

That great advantages have resulted, and that greater still will result from the discovery of the Photographic art, few will deny. The faithful manner in which it copies nature, even to the most minute details, renders it of much value to the painter ; but a few minutes sufficing to take a view that formerly would have occupied several days. Its superiority in portraits, over miniature or oil painting has been tacitly acknowledged by the thousands who employ it to secure their own, or a friends likeness, and by the steady increase in the number of artists who are weekly, aye daily springing up in every town and village in the land.

CHAP. III.

SYNOPSIS OF MR. HUNT'S TREATISE ON "THE INFLUENCE OF THE SOLAR RAYS ON COMPOUND BODIES, WITH ESPECIAL REFERENCE TO THEIR PHOTOGRAPHIC APPLICATION."

OXIDE OF SILVER exposed for a few hours to good sunshine, passes into a more decided olive color, than characterises it when first prepared by precipitation from nitrate of silver. Longer exposure renders this color very much lighter, and the covered parts, are found much darker, than those on which the light has acted directly. In some instances where the oxide of silver has been spread on the paper a decided whitening process in some parts, after a few days exposure, is noticed. Oxide of silver disolved in ammonia is a valuable photographic fluid ; one application of a strong solution forming an exceedingly sensitive surface. The pictures on this paper are easily fixed by salt or weak ammonia.

NITRATE OF SILVER.—This salt in a state of purity, does not appear to be sensibly affected by light, but the presence of the smallest portion of organic matter renders it exceedingly liable to change under luminous influence.

If a piece of nitrated paper is placed upon hot iron, or held near the fire, it will be found that at a heat just below that at which the paper chars, the salt is decomposed. Where the heat is greatest, the silver is revived,

and immediately around it, the paper becomes a deep blue; beyond this a pretty decided green color results, and beyond the green, a yellow or yellow brown stain is made. This exhibits a remarkable analogy between heat and light,—before spoken of in chap. II—and is of some practical importance in the preparation of the paper.

PRISMATIC ANALYSIS.—The method of accomplishing the prismatic decomposition of rays of light by the spectrum has already been described on pages 22 and 23. The color of the impressed spectrum, on paper washed with nitrate of silver, is at first, a pale brown, which passes slowly into a deeper shade; that portion corresponding with the blue rays becoming a blue brown; and under the violet of a peculiar pinkey shade, a very decided green tint, on the point which corresponds with the least refrangible blue rays, may be observed, its limits of action being near the centre of the yellow ray, and its maximum about the centre of the blue, although the action up to the edge of the violet ray is continued with very little diminution of effect; beyond this point the action is very feeble.

When the spectrum is made to act on paper which has been previously darkened, by exposure to sunshine under cupro-sulphate of ammonia, the phenomena are materially different. The photographic spectrum is lengthened out on the red or negative side by a faint but very visible red portion, which extends fully up to the end of the red rays, as seen by the naked eye. The tint of the general spectrum, too, instead of brown is dark grey, passing, however, at its most refracted or positive end into a ruddy brown.

In its Photographic application, the nitrate of silver is

the most valuable of the salts of that metal, as from it most of the other argentine compounds can be prepared, although it is not of itself sufficiently sensible to light to render it of much use.

CHLORIDE OF SILVER.—This salt of silver, whether in its precipitated state, or when fused, changes its color to a fine bluish grey by a very short exposure to the sun's rays. If combined with a small quantity of nitrate, the change is more rapid, it attains a deep brown, then slowly passes into a fine olive, and eventually, after a few weeks, the metalic silver is seen to be revived on the surface of the salt. Great differences of color are produced on chlorides of silver precipitated by different muriates. Nearly every variety in combination with the nitrate, becomes *at last* of the same olive color, the following examples, therefore, have reference to a few minutes exposure, only, to good sunshine; it must also be recollected that the chloride of silver in these cases is contaminated with the precipitant.

Muriate of ammonia precipitates chloride to darken to a fine chocolate brown, whilst muriate of lime produces a brick-red color. Muriates of potash and soda afford a precipitate, which darkens speedly to a pure dark brown, and muriatic acid, or aqueous chlorine, do not appear to increase the darkening power beyond the lilac to which the pure chloride of silver changes by exposure. This difference of color appears to be owing to the admixture of the earth or alkali used with the silver salt.

The prismatic impression on paper spread with the chloride of silver is often very beautifully tinted, the intensity of color varying with the kind of muriate used. Spread paper with muriate of ammonia or baryta and you obtain a range of colors nearly corresponding with the

natural hues of the prismatic spectrum. Under favorable
circumstances the mean red ray, leaves a red impression,
which passes into a green over the space occupied by the
yellow rays. Above this a leaden hue is observed, and
about the mean blue ray, where the action is greatest, it
rapidly passes through brown into black, and through the
most refrangible rays it gradually declines into a bluish
brown, which tint is continued throughout the invisible
rays. At the least refrangible end of the spectrum, the very
remarkable phenomenon has been observed, of the extreme
red rays exerting a protecting influence, and preserving
the paper from that change, which it would otherwise
undergo, under the influence of the dispersed light which
always surrounds the spectrum. Not only the extreme red
ray exerts this very peculiar property, but the ordinary
red ray through nearly its whole length.

In photographic drawing this salt is of the utmost im-
portance. Mr. Talbot's application of it will be given
hereafter in another portion of this work.

Iodide of silver—Perfectly pure, undergoes very
little change under the influence of light or heat ; but if
a very slight excess of the nitrate of silver be added it
becomes infinitely more senitive than the chloride

The spectrum impressed upon paper prepared with a
weak solution of the hydriodate of potash presents some
very remarkable peculiarities. The maximum of intensity
is found at the edge of the most refrangible violet rays,
or a little beyond it, varying slightly according to the
kind of paper used, and the quantity of free nitrate of
silver present. The action commences at a point
nearly coincident with the mean red of the luminous
spectrum, where it gives a dull ash or lead color, while
the most refrangible rays impress a ruddy snuff-brown,

the change of tint coming on rather suddenly about the end of the blue or beginning of the violet rays of the luminous spectrum. Beyond the extreme violet rays, the action rapidly diminishes, but the darkening produced by these invisible rays, extends a very small space beyond the point at which they cease to act on the chloride of silver.

In its photographic application, it is, alone, of very little use; but in combination with other re-agents it becomes exquisitely sensitive. With gallic acid and the ferrocyanate of potash it forms two of the most sensitive photographic solutions with which we are acquainted. These are used in the calotype process.

IODURET OF SILVER.—If upon a plate of polished silver we place a small piece of iodine, and apply the heat of a lamp beneath the plate for a moment, a system of rings is speedily formed. The first ring, which spreading constantly forms the exterior of the circle, is of a bright yellow color; within this, there arises, successively, rings of green, red and blue colors, and then again a fine yellow circle, centred by a greyish spot on the place occupied by the iodine. On exposing these to the light, the outer yellow circle almost instantly changes color, the others slowly, in the order of their position, the interior yellow circle resisting for a long time the solar influence. These rings must be regarded as films of the ioduret of silver, varying, not only in thickness, but in the more or less perfect states of combination in which the iodine and metal are. The exterior circle is an ioduret in a very loose state of chemical agregation ; the attractive forces increase as we proceed towards the centre, where a well formed ioduret, or probably a true iodide of silver, is formed, which is acted upon by sunlight with difficulty. The exterior and most

sensitive film constitutes the surface of Daguerreotype plates. The changes which these colored rings undergo are remarkable; by a few minutes exposure to sunlight, an inversion of nearly all the colors takes place, the two first rings becoming a deep olive green; and a deep blue inclining to black.

The nature of the change which the ioduret of silver undergoes on Daguerreotype plates, through the action of light, Mr. Hunt considers to be a decided case of decomposition, and cites several circumstances in proof of his position. These with other facts given by Mr. Hunt in his great work on the Photographic art, but to volumnious to include in a volume of the size to which I am obliged to cofine myself, should be thoroughly studied by all Daguerreotypists.

PRISMATIC ANALYSIS.—The most refrangible portion of the spectrum, (on a Daguerreotype plate) appears, after the plate has been exposed to the vapor of mercury, to have impressed its colors; the light and delicate film of mercury, which covers that portion, assuming a fine blue tint about the central parts, which are gradually shaded off into a pale grey; and this is again surrounded by a very delicate rose hue, which is lost in a band of pure white. Beyond this a protecting influence is powerfully exerted; and notwithstanding the action of the dispersed light, which is very evident over the plate, a line is left, perfectly free from mercurial vapor, and which, consequently, when viewed by a side light, appears quite dark. The green rays are represented by a line of a corresponding tint, considerably less in size than the luminous green rays. The yellow rays appear to be without action, or to act negatively, the space upon which they fall being protected from the mercurial vapor; and it

consequently is seen as a dark band. A white line of vapor marks the place of the orange rays. The red rays effect the sensitive surface in a peculiar manner; and we have the mercurial vapor, assuming a molecular arrangement which gives to it a fine rose hue; this tint is surrounded by a line of white vapor, shaded at the lowest extremity with a very soft green. Over the space occupied by the extreme red rays, a protecting influence is again exerted; the space is retained free from mercurial vapor and the band is found to surround the whole of the least refrangible rays, and to unite itself with the band which surrounds the rays of greatest refrangibility. This band is not equally well defined throughout its whole extent. It is most evident from the extreme red to the green; it fades in passing through the blue, and increases again, as it leaves the indigo, until beyond the invisible chemical rays it is nearly as strong as it is at the calorific end of the spectrum.

Images on Daguerreotype plates which have been completely obliterated by rubbing may be restored, by placing it in a tolerably strong solution of iodine in water.

BROMIDE OF SILVER.—This salt, like the iodide, does not appear to be readily changed by the action of light; but when combined with the nitrate of silver it forms a very sensitive photographic preparation.

Paper prepared with this salt, blackens over its whole extent with nearly equal intensity, when submitted to the prismatic spectrum. The most characteristic peculiarity of the spectrum is its extravagant length. Instead of terminating at the mean yellow ray, the darkened portion extends down to the very extremity of the visible red rays. In tint it is pretty uniformly of a grey-black over its whole extent, except that a slight fringe of redness is

perceptible at the least refracted end. Beyond the red ray an extended space is protected from the agency of the dispersed light, and its whiteness maintained ; thus confirming the evidence of some chemical power in action, over a space beyond the luminous spectrum, which corresponds with the rays of the least refrangibility.

This salt is extensively used in photographic drawing.

PREPARATIONS OF GOLD.—*Chloride of Gold*, freed from an excess of acid is slowly changed under the action of light ; a regularly increasing darkness taking place until it becomes purple, the first action of the light being to whiten the paper, which, if removed from the light at this stage, will gradually darken and eventually develope the picture. This process may be quickened by placing the paper in cold water.

Chloride of gold with nitrate of silver gives a precipitate of a yellow brown color. Paper impregnated with the acetate of lead, when washed with perfectly neutral chloride of gold, acquires a brownish-yellow hue. The first impression of light seems rather to whiten than darken the paper, by discharging the original color, and substituting for it a pale greyish tint, which by slow degrees increases to a dark slate color ; but if arrested, while yet, not more than a moderate ash grey, and held in a current of *steam*, the color of the parts acted upon by light—and of that only—darkens immediately to a deep purple.

Here I must leave the subject of the action of light upon metalic compounds—referring to Mr. Hunts work for any further information the student may desire on the other metals—as I find myself going beyond my limits. I cannot, however, entirely dismiss the subject without giving a few examples of the action of light on the juices

of plants, some of which produce very good photographic effect.

CORCHORUS JAPONICA—The juice of the flowers of this plant impart a fine yellow color to paper, and, so far as ascertained, is the most sensitive of any vegetable preparation ; but owing to its continuing to change color even in the dark, photographic images taken on paper prepared with it soon fade out.

WALL FLOWER.—This flower yields a juice, when expressed with alcohol, from which subsides, on standing, a bright yellow finely divided fæcula, leaving a greenish-yellow transparent liquid, only slightly colored supernatant. The fæcula spreads well on paper, and is very sensitive to light, but appears at the same time to undergo a sort of chromatic analysis, and to comport itself as if composed of two very distinct coloring principles, very differently affected. The one on which the intensity and sub-orange tint of the color depends, is speedily destroyed, but the paper is not thereby fully whitened. A paler yellow remains as a residual tint, and this on continued exposure to the light, slowly darkens to brown. Exposed to the spectrum, the paper is first reduced nearly to whiteness in the region of the blue and violet rays. More slowly, an insulated solar image is whitened in the less refrangible portion of the red. Continue the exposure, and a brown impression begins to be percieved in the midst of the white streak, which darkens slowly over the region between the lower blue and extreme violet rays.

THE RED POPPY yields a very beautiful red color, which is entirely destroyed by light. When perfectly dried on paper the color becomes blue. This blue color is speedily discharged by exposure to the sun's rays, and papers prepared with it afford very interesting photographs.—

Future experiments will undoubtedly more fully develope the photogenic properties of flowers, and practically apply them.

Certain precautions are necessary in extracting the coloring matter of flowers. The petals of fresh flowers, carefully selected, are crushed to a pulp in a mortar, either alone or with the addition of a litte alcohol, and the juice expressed by squeezing the pulp in a clean linen or cotton cloth. It is then to be spread upon paper with a flat brush, and dried in the air. If alcohol be not added, it must be applied immediately, as the air changes or destroys the color instantly.

Most flowers give out their coloring matter to alcohol or water—but the former is found to weaken, and in some cases to discharge altogether these colors ; but they are in most cases restored in drying. Paper tinged with vegetable colors must be kept perfectly dry and in darkness.

To secure an eveness of tint on paper it should be first moistened on the back by sponging, and blotting off with bibulous paper. It should then be pinned on a board, the moist side downwards, so that two of its edges—the right and lower ones—project a little over those of the board. Incline the board twenty or thirty degrees to the horizon, and apply the tincture with a brush in strokes from right to left, taking care *not to go over* the edges which rests on the board, but to pass clearly over those that project ; and also observing to carry the tint from below upwards by quick sweeping strokes, leaving no dry spaces between them. Cross these with other strokes from above downwards, leaving no floating liquid on the paper. Dry as quickly as possible, avoiding, however, such heat as may injure the tint

CHAP. IV.

THERE are very few who may not be capable of prac-
tising the Photographic art, either on paper, or metalic
plates—but, like all other professions, some are more
clever in its various processes than others.

Impatience is a great drawback to perfect success, and
combined with laziness is a decided enemy. Besides
this, no one can *excel* in Photography who does not pos-
sess a natural taste for the fine arts, who is not quick in
discerning grace and beauty—is regardless of the prin-
ciples of perspective, foreshorting and other rules of
drawing, and who sets about it merely for the sake of
gain—without the least ambition to rise to the first rank,
both in its practice and theory. There is no profession
or trade in which a slovenly manner will not show itself,
and none where its effects will be more apparent than
this.

In order to be great in any pursuit, we must be our-
selves, and keep all things, in order. In your show and
reception rooms, let neatness prevail; have your speci-
mens so placed—leaning slightly forward—as to obtain
the strongest light upon them, and at the same time pre-
vent that glassiness of apearance which detracts so ma-
terially from the effect they are intended to produce. If
possible, let the light be of a north-western aspect, mel-

lowed by curtains of a semi-transparent hue. Your show-cases, at the door, should be kept well cleaned. I have often been disgusted while attempting to examine por-traits in the cases of our artists, at the greasy coating and marks of dirty fingers upon the glass and frame enclosing them. Believe it, many a good customer is lost for no other reason.

In your operating room, dust should be carefully ex-cluded. It should be furnished with nothing apt to col-lect and retain dust; a carpet is therefore not only a use-less article, but very improper. A bare floor is to be prefered; but if you must cover it use matting. There is no place about your establishment where greater care should be taken to have order and cleanliness; for it will prevent many failures often attributed to other causes. " A place for every thing, and every thing in its place," should be an absolute maxim with all artists. Do not oblige the ladies, on going away from your rooms, to say—" That H. is a slovenly man; see how my dress is ruined by sitting down in a chair that looked as if it had just come out of a porter house kitchen and had not been cleaned for six months."

In choosing your operating room, obtain one with a north-western aspect, if possible; and either with, or ca-pable of having attached, a large sky-light. Good pic-tures may be taken without the sky-light, but not the most pleasing or effective.

A very important point to be observed, is to keep the camera perfectly free from dust. The operator should be careful to see that the slightest particle be removed, for the act of inserting the plate-holder will set it in mo-tion, if left, and cause those little black spots on the plate, by which an otherwise good picture is spoiled.

The camera should be so placed as to prevent the sun shining into the lenses.

In taking portraits, the conformation of the sitter should be minutely studied to enable you to place her or him in a position the most graceful and easy to be obtained. The eyes should be fixed on some object a little above the camera, and to one side—but never into, or on the instrument, as some direct ; the latter generally gives a fixed, silly, staring, scowling or painful expression to the face. Care should also be taken, that the hands and feet, in whatever position, are not too forward or back ward from the face when that is in good focus

If any large surface of white is present, such as the shirt front, or lady's handkerchief, a piece of dark cloth (a temporary bosom of nankeen is best,) may be put over it, but quickly withdrawn when the process is about two thirds finished.

A very pleasing effect is given to portraits, by introducing, behind the sitter, an engraving or other picture— if a painting, avoid those in which warm and glowing tints predominate. The subject of these pictures may be applicable to the taste or occupation of the person whose portrait you are taking. This adds much to the interest of the picture, which is otherwise frequently dull, cold and inanimate.

Mr. J. H. Whitehurst of Richmond, Va., has introduced a revolving background, which is set in motion during the operation, and produces a distinctness and boldness in the image not otherwise to be obtained. The effect upon the background of the plate is equally pleasing ; it having the appearance of a beautifully clouded sky.

In practising Photographic drawing on paper, the stu-

dent must bear in mind that it is positively essential, to secure success in the various processes, to use the utmost precaution in spreading the solutions, and washes from the combination of which the sensitive surfaces result. The same brush should always be used for the same solution, and never used for any other, and always washed in clean water after having been employed. Any metalic mounting on the brushes should be avoided, as the metal precipitates the silver from its solution. The brushes should be made of camels or badger's hair and sufficiently broad and large to cover the paper in two or three sweeps; for if small ones be employed, many strokes must be given, which leave corresponding streaks that will become visible when submitted to light, and spoil the picture.

These few preliminary hints and suggestions, will, I trust, be of some service to all who adopt this pleasing art as a profession ; and will, with a due attention to the directions given in the practical working of the Daguerreotype, Calotype, etc., ensure a corresponding measure of success.

THE entire Daguerreotype process is comprised in seven distinct operations ; viz:

1.—*Cleaning and polishing the plate.*

2.—*Applying the sensitive coating.*

3 —*Submitting the plate to the action of light in the camera.*

4.—*Bringing out the picture ; in other words rendering it visible.*

5.—*Fixing the image, or making it perminent—so that the light may no longer act upon it.*

6.—*Gilding : or covering the picture with a thin film of gold*—which not only protects it, but greatly improves its distinctness and tone of color.

7.—*Coloring the picture.*

For these various operations the following articles— which make up the entire apparatus of a Daguerrean ar- tist—must be procured

1.—THE CAMERA.—(*Fig.* 5.). The Camera Obscura of the Italian philosophers, although highly appreciated, on account of the magical character of the pictures it pro- duced, remained little other than a scientific toy, until the discovery of M. Daguerre. The value of this instrument is now great, and the interest of the process which it so

essentially aids, universally admitted. A full description
of it will therefore be interesting.

FIG. 5.

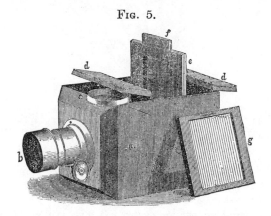

The camera is a dark box (*a*), having a tube with len-
ses (*b*) placed in one end of it, through which the ra-
diations from external objects pass, and form a diminished
picture upon the ground glass (*g*) placed at the proper
distance in the box to receive it ; the cap *c* covering the
lenses at *b* until the plate is ready to receive the image of
the object to be copied.

Thus *a* (*fig.* 6.) representing the lens, and *b* the object
desired to be represented, the rays (*c, c*) proceeding from
it fall upon the lens, and are transmitted to a point, which
varies with the curvature of the glass, where an inverted
image (*d*) of *b* is very accurately formed. At this point,
termed the focus, the sensitive photographic material is
placed for the purpose of obtaining the required picture.

The great disideratum in a photographic camera is
perfect lenses. They should be achromatic, and the utmost

Fig. 6.

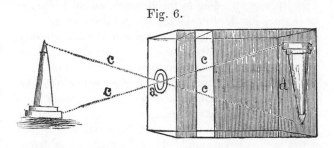

transparency should be obtained; and under the closest inspection of the glass not the slightest wavy appearance, or dark spot should be detected; and a curvature which as much as possible prevents spherical aberration should be secured. The effect produced by this last defect is a convergence of perpendiculars, as for instance; two towers of any building, would be represented as leaning towards each other; and in a portrait the features would seem contracted, distorted and mingled together, so as to throw the picture out of drawing and make it look more like a caricature than a likeness. If the lens be not achromatic, a chromatic aberration takes place, which produces an indistinct, hazy appearance around the edges of the picture, arising from the blending of the rays.

The diameter and focal length of a lens must depend in a great measure on the distance of the object, and also on the superficies of the plate or paper to be covered. For portraits one of 1½ inches diameter, and from 4½ to 5½ inches focus may be used; but for distant views, one from 2 inches to 3 inches diameter, and from 8 to 12 inches focal length will answer much better. For single lenses, the aperture in front should be placed at a distance

from it, corresponding to the diameter, and of a size not more than one third of the same. A variety of movable diaphrams or caps, to cover the aperture in front, are very useful, as the intensity of the light may be modified by them and more or less distinctness and clearness of delineation obtained. These caps alway come with Voitlander instruments and should be secured by the purchaser.

Though the single acromatic lens answers very well for copying engravings; taking views from nature or art, for portraits the double should always be used. The extensive manufacture of the most approved cameras, both in Europe and in this country, obviates all necessity for any one attempting to construct one for their own use. Lenses are now made so perfect by some artisans that, what is called the " quick working camera " will take a picture in one second, while the ordinary cameras require from eight to sixty.

The camera in most general use is that manufactured by Voitlander and Son of Germany. Their small size consists of two seperate acromatic lenses ; the first, or external one, has a free aperture of 1¼ inches ; the second, or internal, 1⅝ inches ; and both have the same focus, viz : 5¾ inches. The larger size differs from the smaller. The inner lens is an achromatic 3¼ inches diameter, its focal length being 30 inches. The outer lens is a meniscus—that is bounded by a concave and convex spherical surface which meet—having a focal length of 18 inches. For every distant view, the aperture in front is contracted by a diaphram to ⅙ of an inch. By this means the light is reflected with considerable intensity and the clearness and correctness of the pictures are truly surprising.

THE AMERICA instruments are constructed on the same

principle and many of them are equally perfect. Mr. Edward Anthony of 205 Broadway, New York city, has constructed, and sold cameras fully equal to the German and for which Voitlander instruments have been refused in exchange by the purchaser.

The ordinary camera box (*see fig.* 5, *a*) varies in size to suit the tube, and is termed medium, half, or whole. Within the box is a slide to assist in regulating the focus, and in enlarging or diminishing the picture. In one end of this slide is a springed groove into which the ground-glass spectrum (*g fig.* 5) is slid, for the purpose of more conveniently arranging the focus. After the plate is prepared it is placed in the holder—partly seen at *e*, fig. 5, and covered with the dark slide *f*, fig. 5 ; the spectrum is then withdrawn and the holder takes its place, and the lids *d, d*, are closed after removing the dark slide *f*. The plate is now ready to receive the image, and the cap *c* may be removed to admit the light into the box.

A camera constructed by Voitlander is thus described by Mr. Fisher. " It is made entirely of brass, so that variations of climate has no effect upon it. It is very portable and when packed in its box, with all the necessary apparatus and materials for practising the Daguerreotype art, occupies but very little space. It is not, however, well adapted for the Calotype process. "

" The brass foot A (fig. 7.), is placed on a table, or other firm support, and the pillar B. screwed into it ; the body of the camera, *C, C* is laid into the double forked bearing *D. D.* The instrument is now properly adjusted by means of the set screws, *e, e, e*, in the brass foot, or it may be raised, lowered, or moved, by the telescope stand, and when correct, fixed by the screw *b*. The landscape to be delineated is viewed either through the

Fig. 7.

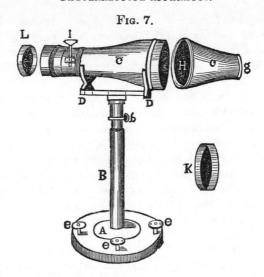

small lens, *g*, or with the naked eye on the ground glass
plate *H*, the focus being adjusted by the screw *I*. The
optical part of the instrument consist of the small set of
achromatic lenses already described. When the portrait
or view is deleniated on the ground glass to the entire sa-
tisfaction of the operator, the brass cap *L* is placed over
the lens, and the entire body is removed away into the
dark, taking care not to disturb the position of the stand.
The body is now detached at the part *H*, and the prepa-
red paper or plate enclosed in the brass frame work intro-
duced in its place ; the whole is again placed upon the
pedestal, the brass cap *L* is removed, by which the paper
or plate is exposed to the full influence of the light, after
which the cap is again replaced.

Mr. Woodbridge, of this city, has constructed an in-
strument for taking full length portraits on plates 10 by

13 inches, which is worthy of some notice. It is a double camera, consisting of two boxes, placed in a frame, one above the other, and so arranged as to slide easily up and down. After the focus has been adjusted, on the object, in both cameras, the plate is put into the upper box, in the manner already described, until the superior portion of the figure is complete; it is then placed in the second box and the lower extremities obtained. The adjustment of the instrument is so complete that

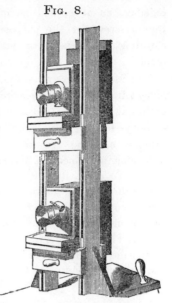

FIG. 8.

a perfect union of the parts is effected in the picture without the least possible line of demarkation being visible. Fig. 8 gives a front view of this instrument.

Fig. 9 represents Talbot's Calotype Camera,—a very beautiful instrument.

The *copying* camera box has an extra slide in the back end, by which it may be considerably lengthened at pleasure.

II.—CAMERA STAND.—The best constructed stands are made of maple or blackwallnut wood, having a cast iron socket (*a*, fig. 12,) through which the sliding rod *b* passes, and into which the legs *c; c*, with iron screw ferules are inserted. The platform *d* is made of two pieces, hinged

together, as at *e*, and having a
thumb screw for the purpose of
elevating or depressing the instru-
ment.

Fig. 9.

III. MERCURY BATH.—Fig. 13
gives a front view of the mercury
bath now in general use in this
country for mercurializing and
bringing out the picture. It is
quite an improvement on those first
used. To make it more portable
it is in three pieces, *a b* and *c*; hav-
ing a groove *e* on one side to receive
the thermometre tube and scale by
which the proper degree of heat-
ing the mercury is ascertained. Into
the top are nicely fitted two or three iron frames, with
shoulders, for the plate to rest in, suitable for the differ-
ent sizes of plates. The bath is heated by means of a
spirit lamp placed under it. From two to four ounces
of highly purified mercury are put into the bath at a time.

IV. PLATE BLOCKS AND VICES.—There are several kinds
of this article in use; I shall describe the two best only.

Fig. 10 gives an idea of the improve-
ment on the English hand block. The
top *a* is perfectly flat and smooth—a
little smaller than the plate, so as to
permit the latter to project a very little
all around—having at opposite angles

Fig. 10.

c c two clasps, one fixed the other moveable, but capable
of being fastened by the thumb screw *d*, so as to secure
the plate tightly upon the block. This block turns upon

a swivle, *b*, which is attached to the table by the screw *c*, This block is only used for holding the plate while undergoing the first operation in cleaning.

Fig. 11.

Fig. 11, shows the form of Lewis' newly patented plate vice, which for durability, simplicity and utility is preferable to all others. It consists of a simple platform and arm of cast iron, the former, *a*, having a groove, *d*, in the centre for fixing the different sizes of plate beds, *e* —and the latter supporting the leaves *e f*. On this vice which is secured to a table, or bench, the plate receives its finishing polish with rouge, or prepared lampblack. Mr. Lewis gives the following directions for its use. "As the cam wears tighten it with the adjusting screw (*g*) so as to allow the lever (*f*) to fall back into a horizontal position ; the plate being in its place at the time. Oil the wearing parts occasionally."

Some Daguerreotypists, however, use a foot lathe with buff wheels of various forms ; but this vice is sufficient for all ordinary purposes.

V. COATING BOXES.—The usual form for iodine and

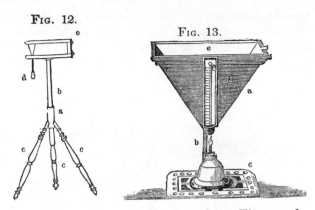

Fig. 12.

Fig. 13.

bromine boxes is seen at figs. 14 and 15. They are far superior to those in use with the English operators. Each consists of a wooden box (*a*,) having firmly embedded within it a stout glass jar (*c*), the edges of which are ground. Over this is placed the sliding cover *b*, double the length of the box, one half occupied by a piece of ground glass (*e*), tightly pressed upon the glass pot by a spring (*i*) beneath the cross bar *g*, and fits the pot so accurately that it effectually prevents the escape of the vapor of the iodine, bromine or other accelerating liquid contained therein. The other half of the lid is cut through, shoulders being left at the four angles for the different sizes of frames, designed to recieve the plate while undergoing the coating process. When the plate is put into the frame, the cover *b* is shoved under the second lid *h* and when coated to the proper degree, it resumes its former position and the plate is placed in the holder of the camera box. To test the tightness of the box, light a piece of paper, put it into the pot and cover it with the sliding lid. The burning paper expels

the air from the pot, and if it be perfectly tight you may raise the whole box by the lid.

VI. GLASS FUNNELS.—Are a necessary article to the Daguerreotypist, for filtering water, solutions, &c.

FIG. 14.

VII. GILDING STAND.—For nervous persons the gilding stand is a useful article. It is adjusted to a perfect level by thumb screws placed in its base.

VIII. SPIRIT LAMPS.—The most useful and economical of those made are the Britania, as they are less liable to break ; and the tube for the wick being fastened to the body by a screw renders it less liable to get out of order or explode. Glass is the cheapest, and for an amateur will do very well, but for a professed artist the Baitania should always be obtained.

IX. COLOR BOX.—These are generally found on sale at the shops, and usually contain eight colors, four brushes and a gold cup. The artist would, however, do well to obtain, all the colors mentioned in the last chapter of this work, and be sure to get the very best, as there are various qualities of the same color, particularly carmine, which is very expensive, and the cupidity of some may induce them to sell a poor article for the sake of larger profits.

Fig. 15.

STILL.—Daguerreotypists should always use distilled water for solutions, and washing the plate, as common water holds various substances in solution which detract very materially from the excellence of a photograph, and often gives much trouble, quite unaccountable to many. For the purpose of distilling water the apparatus represented at Fig. 16 is both convenient and economical.

It may be either wholly of good stout tin, or of sheet iron tinned on the inside, and may be used over a common fire, or on a stove. *A* is the body, which may be made to hold from one to four gallons of water, which is introduced at the opening *b*, which is then stopped by a cork. The tube *d* connects the neck *a* of the still with the worm tub, or refrigerator *B*, at *e*, which is kept filled with *cold* water by means of the funnel *c*, and drawn off as fast as it becomes warm by the cock *f*. The distilled water is condensed in the worm—and passes off at the cock *b*, under which a bottle, or other vessel, should be placed to receive it. The different joints are rendered tight by lute, or in its absence, some stiff paste spread upon a piece of linen and wrapped around them will an-

swer very well ; an addition of sealing wax over all will make them doubly secure.

Fig. 16.

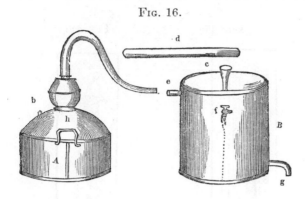

HYGROMETER.—This is an instrument never to be found, I believe, in the rooms of our operators, although it would be of much use to them, for ascertaining the quantity of moisture floating about the room ; and as it is necessary to have the atmosphere as dry as possible to prevent an undue absorption of this watery vapor by the iodine &c., and to procure good pictures,—its detection becomes a matter of importance. Mason's hygrometer, manufactured by Mr. Roach and sold by Mr. Anthony, 205 Broadway, New York is the best in use.

It consists of two thermometre tubes placed, side by side, on a metalic scale, which is graduated equally to both tubes. The bulb of one of these tubes communicates, by means of a net-work of cotton, with a glass reservoir of water attached to the back of the scale. Fig. 17 and 18 represent a front and back view of this instrument.

Fig. 17 is the front view, showing the tubes with their
respective scales ; the bulb *b* being covered with the net-
work of cotton communicating with the reservoir *c* fig.

FIG. 17 FIG. 18.

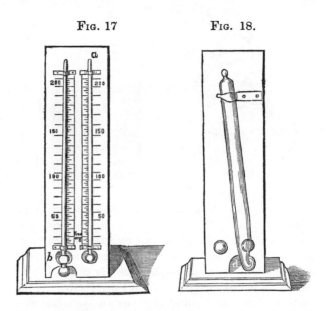

18, at *d*. The evaporation of the water from this bulb
decreases the temperature of the mercury in the tube *b*
in proportion to the dryness of the atmosphere, and the
number of degrees the tube *b* indicates below that of the
other, shows the real state of the atmosphere in the room ;
for instance, if *b* stands at forty and *a* at sixty-one the
room is in a state of extreme dryness, the difference of
twenty-one degrees between the thermometers—let *a*
stand at any one point—gives this result. If they do not
differ, or there is only four or five degrees variation, the

atmosphere of the room is very moist and means should be taken to expel the superfluous quantity.

HEAD RESTS.—The button head rest with chair back clip, A fig. 19—is much the best for travelling artists, as it can be taken apart, into several pieces and closely packed ; is easily and firmly fixed to the back of a chair by the clamp and screw a and b, and is readily adjusted to the head, as the buttons c, c and arms d, d are movable.

Sometimes the button rest is fixed to a pole, which is screwed to the chair ; but this method is not so secure and solid as the clip and occupies more room in packing. Both the pole and clip, are furnished in some cases with brass band rests instead of the button ; but the only recommendation these can possibly possess in the eyes of any artist, is their cheapness.

FIG. 19.

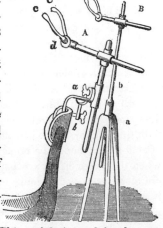

For a Daguerreotypist permanently located the independent iron head-rest, B fig. 19, is the most preferable, principally on account of its solidity. It is entirely of iron, is supported by a tripod a) of the same metal and can be elevated by means of a rod (b) passing through the body of the tripod, to a height sufficient for a person, standing, to rest against.

GALVANIC BATTERY.—This article is used for the purpose of giving to imperfectly coated plates a thicker covering of silver. The form of battery now most uni-

versally employed for electrotype, and other galvanic
purposes, is Smee's—Fig. 20.

It consists of a piece of pla-
tinized silver, A, on the top
of which is fixed a beam of
wood, B, to prevent contact
with the silver. A binding
screw C is soldered on to the
silver plate to connect it with
any desired object, by means
of the copper wire, e. A
plate of amalgamated zinc,
D, varying with the fancy of
the operator from one half to
the entire width of the silver,
is placed on each side of the
wood. This is set into a glass
vessel, P,—the extreme ends
of the wood resting upon its
edge—on which the acid
with which it is charged has

FIG. 20.

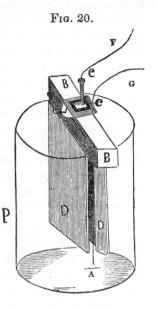

no effect. The jar is charged with sulphurid acid, (com-
mon oil of vitriol) diluted in eight parts its bulk of water.
The zinc plates of the battery have been amalgamated
with quicksilver, and when the battery is set into the jar
of acid there should be no action percieved upon them
when the poles F, G, are not in contact. Should any
action be percieved, it indicates imperfect amalgamation ;
this can be easily remedied by pouring a little mercury
upon them immediately after removing them from the
acid, taking care to get none upon the centre plate A.

Directions for use.—A sheet of silver must be attached
to the wire connected with the centre plate A of the

battery, and placed in the silver solution—prepared as directed below. The plate to be silvered is first cleaned with diluted sulphuric acid, and then attached to the wire, G, proceeding from the zinc plates D, D, and placed in the silver solution, opposite the silver plate attached to the pole F, and about half an inch from it. A slight effervescence will now be percieved from the battery, and the silver will be deposited upon the Daguerreotype plate, while at the same time a portion of the silver plate is dissolved.

To prepare the solution of silver.—Dissolve one ounce of chloride of silver in a solution of two ounces of cyanide of potassium, previously dissolved in one quart of water. The oxide of silver may be used instead of the chloride. This solution is put into a tumbler, or other vessel.

FIG. 21.

FIG. 22.

This battery with the necessary articles for using it may be obtained of E. Anthony, 205 Broadway, New York city.

The other articles required by every operator may be simply enumerated, viz :

Stickng, or sealing paper.

A pair of pliers, or forceps.

Porcelain pans or dishes, for applying the hyposul-

phite of soda and washing after the imagine is fixed, something in form like fig. 23.

A support for holding the plate while being washed, like fig. 24

FIG. 25.

BUFF STICKS.—*Fig.* 25.—These are usually from one to three feet in length, and about three inches wide—some think two and a half sufficient. The underside, which is convex, is covered with a strip of finely prepared buckskin, or velvet, well padded with cotton or tow.

All the articles enumerated in this chapter may be obtained, of the very best quality and at the most reasonable rates, of Mr. E. Anthony, 205, Broadway, New York.

CHAP. VI.

THE DAGUERREOTYPE PROCESS.

The process of taking Daguerreotype pictures differs very materially from all others of the photographic art, inasmuch as the production of the image is effected upon plates of copper coated with silver. The silver employed should be as pure as possible; the thickness of the plate is of little consequence, provided there be sufficient silver to bear the cleaning and polishing—is free from copper spots, is susceptible of a high polish, an exquisitely sensitive coating and a pleasing tone. These qualities are possessed to an eminent degree by the French plates.

Having already enumerated the various processes—and the apparatus necessary for the manipulation, I will here give a list of the chemicals to be used, and then proceed to explain them more fully. The requisite chemicals are—

NITRIC ACID,	ROUGE,
DRY IODINE,	MERCURY,
DRYING POWDER,	HYPOSULPHITE OF SODA,
CYANIDE OF POTASSIUM,	CHLORIDE OF GOLD; OR
ROTTENSTONE,	HYPOSULPHITE OF GOLD.
TRIPOLI,	CHLORIDE OF SILVER.

CHLORIDE OF IODINE, } their compounds, or other accelerating mixtures.
BROMINE

FIRST OPERATION.—*Cleaning and polishing the plate.*—For this purpose the operator will require the—

Plate Blocks,

Plate Vice

Spirit Lamp,

Polishing Buffs,

Nitric Acid, diluted in fifteen times its bulk of water

Galvanic Battery, to galvanize the plate, if it is too imperfect to be used without, previous cleaning it, as directed in the last chapter.

Rottenstone,

Tripoli, which is too often dispensed with.

Rouge, or lampblack—the first being most preferable. The English operators mix the two together.

Prepared cotton Wool, or Canton flannel. If the first is used, it should be excluded from the dust, as it is not so easily cleansed as the latter.

The plate is secured, with its silver side upward, to the block, by the means described on page 58—having previously turned the edges backward all around. The amount of cleaning a plate requires, depends upon the state it is in. We will suppose one in the worst condition ; dirty, scratched, and full of mercury spots, all of which imperfections are more or less to be encountered. The mercury spots are to be removed by burning the plate. To do this hold the plate over the flame of a spirit lamp, more particularly under the mercury spots, until they assume a dull appearance, when the lamp is to be removed, and the plate allowed to cool, after which it is attached to the block.

Place the block upon the swivle, and hold it firmly with the left hand ; take a small knot or pellet of cotton, or, if you like it better, a small piece of canton flannel— wet it with a little diluted nitric acid ; then sift some fine-

ly prepared rottenstone—Davie's,* if you can get it—upon it, and rub it over the plate with a continual circular motion, till all traces of the dirt and scratches are removed ; then wipe off the rottenstone with a clean piece of cotton, adopting, as before, a slight circular motion, at the same time wiping the edges of the plate. Even the back should not be neglected, but throughly cleansed from any dirt or greasy film it may have received from handling.

When this is thoroughly accomplished, mix a portion of your tripoli with the dilute nitric acid, to the consistence of thick cream. Then take a pellet of cotton and well polish the plate with this mixture, in the same manner as with the rottenstone. Continue the process till, on removing the tripoli with a clean pellet, the plate exhibits a clear, smooth, bright surface, free from all spots, or scratches. Any remains of the acid on the plate may be entirely removed by sifting on it a little Drying powder, and then wiping it carefully off with a fine camels hair brush, or duster. The finishing polish is now to be given.

For this purpose the rouge—or a mixture of rouge and lamp-black, in the proportion of one part of the former to seven of the latter—is used. It should be kept either in a muslin bag, or wide mouth bottle, over which a piece of muslin is tied—in fact, both the rottenstone and tripoli should be preserved from the dust in the same manner. With a little of this powder spread over the buff—described on page 53—the plate recieves its final polish ; the circular motion is changed for a straight one across the plate, which, if intended for a portrait, should be buffed the narrow way ; but if, for a landscape or view of a house, the length way of the plate.

* Sold by E. Anthony.

The operation of cleaning the plate at first appears difficult and tedious, and many have been deterred from attempting this interesting art on that account ; but, in reality, it is more simple in practice than in description, and with a little patience and observation, all difficulties are easily overcome. Great care must be taken to keep the buff free from all extraneous matter, and perfectly dry, and when not in use it should be wrapped up in tissue paper, or placed in a tight box.

The plate should be buffed immediately before the sensitive coating is given ; particles of dust are thus effectually removed ; the temperature of the plate is also increased by the friction, and the required tint more readily obtained.

SECOND OPERATION.— *Applying the sensative coating.*— The apparatus and chemicals required, are an

Iodine box—see fig. 14 *page* 53.

Bromine box—similar to the iodine box, but a trifle deeper.

Dry Iodine.

Bromine, or a compound of Bromine and Chloride of Iodine, or other sensitive mixture.

Most of our best operators use the compound Bromine and Chloride of Iodine. In the early days of the Daguerreotype, Iodine alone was used in preparing the plate, and although it still plays a very important part, other preparations, called accelerating liquids, quickstuff, &c., are used, and the discovery of which has alone ensured the application of the Daguerreotype successfully to portrait taking—for when first introduced among us it took from five to ten minutes to produce a tolerable good view, while now but the fraction of a minute is required to obtain an accurate likeness.

To iodize the plate perfectly it must be placed over the iodine vapor immediately after buffing. Scatter from a sixteenth to the eighth of an ounce of dry iodine over the bottom of your coating box, and slightly cover it with cotton wool. The plate is then dropped into the frame *b, fig.* 12, with its silvered surface downward, and thrust under the lid *h*. The bright surface of the plate is soon coated with a film of iodine of a fine yellow color ; it is then removed and placed over the accelerating solution. It is not absolutely necessary to perform this operation in the dark, although a bright light should be avoided. Not so the next part of the process, viz; giving the plate its extreme sensitiveness, or coating with the accelerating liquids. In this great caution should be used to prevent the slightest ray of light impringing directly on the plate, and in examining the color reflected light should always be used. A convient method of examining the plate, is to make a small hole in the partition of the closet in which you coat, and cover it with a piece of tissue paper ; by quickly turning the plate so that the paper is reflected upon it the color is very distinctly shown. Most of our operators are not so particular in this respect as they should be.

ACCELERATING LIQUID.—Of these there are several kinds, which differ both in composition and action—some acting very quickly, others giving a finer tone to the picture although they are not so expeditious in there operations; or in other words, not so sensitve to the action of light. These are adopted by Daguerreotypists according to their tastes and predjudices. They are all applied in the same way as the coating of iodine. The following are the best.

Bromine water—This solution is much used in France,

and, I shall therefore give its preparation, and the method of using it, in the words of M. Figeau. " Put into a bottle of pure water, a large excess of bromine; shake the mixture well, and before using it, let all the bromine be taken up. An ascertained quantity of this saturated water is then diluted in a given quantity of distilled water, which gives a solution of bromine that is always identical. " M. Figeau recommends one part of the saturated solution to thirty parts its bulk of water ; but M. Lesebour finds it more manageable if diluted with forty times. In case pure distilled, or rain water cannot be procured, a few drops of nitric acid—say six to the quart—should be added to the common water.

Put into the bromine box a given quantity of this solution, sufficient to well cover the bottom ; the plate, having been iodized to a deep yellow, is placed over it; the time the plate should be exposed must be ascertained by making a few trials ; it averages from twelve to forty seconds. When once ascertained, it is the same for any number of plates, as the solution, which of course would become weaker and weaker, is changed after every operation, the same quantity being always put into the pot.

Chloride of Iodine.—This is prepared by introducing chlorine gass into a glass vessel containing iodine ; the iodine is liquified, and the above named compound is the result. Operators need not, however, be at the trouble and expense of preparing it, as it can be obtained prefectly pure of Mr. Anthony, 205 Broadway, N. Y., as also all of the chemicals herein enumerated. The compound is diluted with distilled water, and the plate submitted to its action till it is of a rose color. Chloride of iodine alone, is seldom if ever used now by American operators, as it does not sufficiently come up to their locomotive princi-

ple of progression. The next is also eschewed by the
majority, although many of our best artists use no other,
on account of the very fine tone it gives to pictures.

Bromide of Iodine.—This is a compound of bromine
and chloride of iodine. In mixing it, much depends upon
the strength of the ingredients; an equal portion of each
being generally used. Perhaps the best method of pre-
paring it, is to make a solution in alcohol of half an
ounce of chloride of iodine, and add the bromine drop
by drop, until the mixture becomes of a dark red color;
then dilute with distilled water, till it assumes a bright
yellow. Put about half an ounce of this compound in-
to the pot, and coat over it to a violet color, change the
solution when it becomes too weak to produce the de-
sired effect.

Another.—Mix half an ounce of bromine with one
ounce of chloride of iodine, add two quarts pure distil-
led water, shake it well and let it stand for twelve hours ;
then add twenty-five drops of muriatic acid, and let it
stand another twelve hours, occasionally shaking it up
well. Dilute six parts of this solution in sixteen of
water. Coat over dry iodine to a deep yellow, then
over the sensitive to a deep rose color—approaching
purple—then back, over dry iodine from four to eight
seconds.

Roach's Tripple Compound.—This is one of the very
best sensitive solutions, and is very popular among Da-
guerreotypists. To use this, take one part in weight, say
one drachm, of the compound and dilute it with twelve
of water ; coat over dry iodine to yellow, then over the
compound to a rosy red. The effect in the camera is
quick, and produces a picture of a fine white tone.

Gurney's Sensitive.—This is another preparation of

bromine, and gives a fine tone. To two parts of water add one of the sensitive, and put just sufficient in the box to cover the bottom, or enable you to coat in from eight to ten seconds. Coat over dry iodine to a dark yellow, and over the quick till you see a good change, then back over the dry iodine from two to three seconds.

Bromide of Lime, or Dry Sensitive.—This is a compound but recently introduced, and is becoming somewhat of a favorite, owing principally to the slight trouble it gives in its preparation, and the tone it imparts to the picture. To prepare it, fill your jar about half or quarter full of dry slacked lime, then drop into it bromine, till it becomes a bright orange red. The plate is generally coated over this compound, after the iodine coating to yellow, to a violet, or plum color; but it will work well under any circumstances, the color being of little consequence, if coated from thirty to ninety seconds, according to its strength.

Mead's Accelerator.—I merely mention this as being in the market, not knowing any thing in regard to its merits. The directions given for its use are as follows: Mix one-third of a bottle with a wine glass full of water, coat the plate over dry iodine to a dark gold color, then over the accelerator to a violet, then back over dry iodine, or chloride of iodine, from three to five seconds.

Chloride of Bromine.—M. Bissou, a French experimentalist, has found that bromine associated with chlorine, prepared in a similar manner to chloride of iodine, already described, a solution of bromine being substituted for the iodine, is a very sensitive solution; by means of it daguerreotype proofs are obtained in half a second, and thus very fugitive subjects are represented, making it the very best compound for taking children. So quick is its

operation, that even persons or animals may be taken in the act of walking.

Hungarian Liquid.—This, I believe, has never been used here, or imported into this country, and the composition of it is not generally known, even in Europe, where it has taken precedence of all others. It acts quickly and with considerable certainty. It is used by diluting it with from ten to fifteen times its bulk of water, putting a sufficient quantity into the jar to cover the bottom. The plate being previously iodized to a light yellow, is submitted to this mixture till it assumes a light rose tint.

Bromine and Fluoric Acid, in combination, are used by some Daguerrean artists as a sensitive, but any of the above compounds are better; besides this, the fluoric acid is a dangerous poison, and the quick made from it will not repay the risk to the health in using it.

As I have before said, great caution should be observed in examining the color of the plate, even by the feeble light allowed, which, when attained, must be immediately placed in the holder belonging to the camera and covered with the dark slide. You then pass to the

THIRD OPERATION.—*Submitting the Plate to the action of Light in the Camera.*—Experience alone must guide the operator as to the time the plate should be exposed to the influence of the light; this being dependent on a variety of circumstances, as clearness of the atmosphere—and here, a reference to the hygrometer will be of advantage—time of day, object to be taken, and the degree of sensitiveness imparted to the plate by the quick-stuff. As I have before said, the artist should be careful to see that the interior of the camera is clean and free from dust, as the small particles flying about, or set in

motion by the sliding of the holder into the box, attach
themselves to the plate, and cause the little black spots,
by which an otherwise good picture is frequently spoiled.
Care should also be taken in withdrawing the dark slide,
in front of the plate, from the holder, as the same effect
may be produced by a too hasty movement. The lens is
the last thing to be uncovered, by withdrawing the cap
c. fig. 5., which should not be done until you have placed
the sitter in the most desirable position. When, accord-
ing to the judgment and experience of the operator, the
plate has remained long enough to receive a good inpres-
sion, the cap is replaced over the lens, and the dark slide
over the plate, which is then removed from the camera.

Daguerreotypists generally mark time by their watches,
arriving at the nearest possible period for producing a
good picture by making several trials. As a ready meth-
od of marking short intervals of time is, however, a very
important consideration, and as any instrument which will
enable an artist to arrive at the exact period, must be an
improvement, and worthy of universal adoption, I will here
describe one invented by Mr. Constable of England, which
he calls a

Sand Clock, or Time Keeper.—" It consists of a glass
tube, about twelve inches long by one in diameter, half
filled with fine sand, similar to that used for the ordinary
minute glasses, and, like them, it has a diaphram, with
a small hole in the centre through which the sand runs.
The tube is attached to a board which revolves on a centre
pin ; on the side is a graduated scale, divided into half
seconds ; the tube is also provided with a moveable in-
dex. This instrument is attached, in a conspicuous
place, to the wall. The glass tube being revolved on its
centre, the index is set to the number of half seconds re-

quired, and the sand running down, the required time is marked without the possibility of error. In practice it will be found to be a far more convenient instrument for the purpose than either a clock or a seconds watch, and is applicable both for the camera and mercury box."

If the artist finds it desirable or necessary to take the object to be copied in its right position, that is reverse the image on the spectrum, he can do so by attaching a mirror (which may be had of Mr. Anthony, or Mr. Roach) to the camera tube, at an angle of forty-five degrees.

If, after taking the plate from the camera, it be examined, no picture will yet be visible, but this is brought about by the

FOURTH PROCESS.—*Bringing out the Picture, or rendering it Visible.*—We now come to the use of the mercury bath, Fig. 11. To the bath a thermometer is attached, to indicate the proper degree of heat required, which should never be raised above 170° Fahrenheit. The plate may be put into one of the frames (see Fig. 11,) over the mercury, face downwards, and examined from time to time, by simply raising it with the fingers, or a pair of plyers. This operation, as well as the others, should take place in the dark closet.

FIG. 27.

Sometimes, to prevent the necessity of raising the plate, an additional cover or top is made use of. It consists of a box fitted closely to the inner rim of the bath, and having an inclined top (a, Fig. 27.) The top is cut through and fitted with frames for each size of plate, like those already described, and in the back is a piece of glass (b,) through which to view the progress

of mercurialization, and an additional piece (c,) on one side, colored yellow, to admit the light. The outline only of the top is here given, in order to show every portion of it at one view.

The picture, being fully developed, is now taken out and examined; it must not, however, be exposed to too strong a light. If any glaring defects be perceived, it is better not to proceed with it, but place it on one side to be re-polished ; if, on the contrary, it appears perfect, you may advance to the

FIFTH OPERATION.—*Fixing the Image so that the light can no longer act upon it.*—The following articles are required for this purpose :

Two or three porcelain or glass dishes, in form, something like fig. 24.

A plate support, fig. 25. Few, I believe, now make use of this, although it is a very convenient article.

Hyposulphite of Soda,

A pair of Plyers.

In Europe, they also use a drying apparatus, Fig. 27, but this, like the plate support, is a matter of little consequence, and may be dispensed with. I will, however, describe it, for the benefit of those who may wish to use it.

FIG. 27.

A vessel made of copper or brass, tinned inside, and large enough to take in the largest plate, but not more than half an inch wide, is the most convenient. It must be kept perfectly clean. Hot distilled water is poured into it, and the temperature kept up by a spirit lamp.

Hyposulphite of Soda.—Having made a solution of

hyposulphite of soda, and well filtered it—the strength
is immaterial ; about half an ounce of the salt to a pint
of distilled water is sufficient—pour it into one of the
porcelain dishes, put into another plain, and into a third
distilled water. · Immerse the plate with its face down-
wards into the hyposulphite, and the whole of the sen-
sitive is removed, and the light has no farther action up-
on it ; it is then to be removed from the hyposulphite
and plunged into the plain water, or placed upon the
support, fig. 25, and the water poured over it. It is
then washed in a similar manner with the distilled water
and well examined, to see that not the slightest particle
of dust rests on the suface. The next step is to dry
it.

This may be readily accomplished by holding the plate
with your plyers, and pouring distilled water over it—if it
is hot, so much the better. Apply the spirit lamp to the
back, at the corner held by the plyers, at the same time
facilitating the operation with the breath ; pass the lamp
gradually downwards, finishing at the extreme corner.
The last drop may now be removed by a little bibulous
paper. A single drop, even, of distilled water allowed to
dry on any part of the surface, is certain to leave a stain
which no after process can remove.

To illustrate the necessity for having perfectly clean
water, and free from all foreign matter—only to be avoid-
ed by using that which is distilled—in these processes,
I will relate a little anecdote.

An operator in this city (New York) frequently made
complaint to me, that his plates were occasionally very
bad; coming out all over in little black and white spots
and spoiling many very good pictures, regretting at the
same time that perfect plates were not made, for he had

lost many customers in consequence of these defects. These complaints being somewhat periodical, I suggested that the fault might be in the hyposulphite, or chloride of gold solutions, or particles of dust floating about in the room, and not in the plate.

A few days after he stated, that his plates having served him again in the same way, he procured a fresh supply of hyposulphite of soda and chloride of gold, but after applying them the result was no better. He then, by my advice, thoroughly cleaned his wash dishes, bottles and *water pail*, made fresh solutions and had no further trouble, becoming satisfied that the plates suffered an undue share of censure.

SIXTH PROCESS.—*Gilding the Picture.*—This is an improvement the honor of which is due to M. Figeau, and may take place either before the drying process, or at any subsequent period; but it improves the picture so materially that it should never be neglected. The articles necessary for gilding are—

A *Pair of Plyars*; *or a Gilding Stand* (*see fig.* 19) *and Chloride* of *Gold*; or *Hyposulphite of Gold.*

The latter is imported by Mr. E. Anthony, 205 Broadway, New York, and is decidedly the best article for the purpose. One bottle simply dissolved in a quart of water will make a very strong solution, and gives a richness to the picture impossible to be obtained from the chloride of gold. The process is precisely similar to that described below for chloride of gold, taking care to *cease the moment* the *bubbles are well defined* over the surface of the plate. Many Daguerreotypists, after a superficial trial, discard the hyposulphite of gold as inferior ; but I have no hesitation in asserting that the fault lies with themselves ; for in every case within my knowledge,

where its use has been persisted in until the correct method has been ascertained, and the nature of the gilding has become familiar, it is always preferred. In illustration of this fact I will relate an anecdote:

A gentleman to whom it had been recommended, purchased a bottle, and after making one or two trials of it, wrote to his correspondent—" Send me two bottles of chloride of gold, for I want no more of the hyposulphite; it is good for nothing." A few weeks after he sent for three bottles of the condemned article, confessing that he had found fault unnecessarily; for, that since he had become familiar to its use, he must acknowledge its superiority, and would use no other gilding.

The Solution of Chloride of Gold is prepared by dissolving in a pint of distilled water, fifteen grains of chrystalized chloride of gold. This solution will be of a yellow tint. In another pint of distilled water dissolve fifty-five grains of hyposulphite of soda; pour gradually, in very small quantities, the gold into the hyposulphite of soda, stirring the solution at intervals; when finished the mixture should be nearly colorless.

Place the plate on its stand, or hold it in the plyers, in a perfectly horrizontal position—silver surface upward—having previously slightly turned up the edges, so that it may hold the solution. Wet the surface with alcohol, letting any superfluous quantity drain off. The alcohol is of no farther use than to facilitate the flowing of the gold mixture over the surface. Now pour on, carefully, as much of the preparation of gold as will remain on the plate. The under part of the plate is then to be heated as uniformly as possible with the spirit lamp; small bubbles will arrise, and the appearance of the portrait or view very sensibly improved. The process must not be

carried too far, but as soon as the bubbles disappear the lamp should be removed, and the plate immersed in distilled water, and dried as before directed.

7th. COLORING THE PICTURE.—I very much doubt the propriety of coloring the daguerreotypes, as I am of opinion, that they are little, if any, improved by the operation, at least as it is now generally practised.

There are several things requisite in an artist to enable him to color a head, or even a landscape effectively, and correctly, and I must say that very few of these are possessed by our operators as a class. These requirements are, a talent for drawing—taste—due discrimination of effect—strict observance of the characteristic points in the features of the subject—quick perception of the beautiful, and a knowledge of the art of mixing colors, and blending tints.

The method now pursued, I do not hesitate to say, and have no fears of being contradicted by those capable of critisizing, is on the whole ruinous to any daguerreotype, and to a perfect one absolutely disgusting. The day may come when accurate coloring may be obtained in the camera. Until that day, if we cannot lead taste into the right channel, we will endeavor to give such instructions that Daguerreotypists may proceed with this part of his work with a better understanding of the principles involved. For this purpose I have prepared a short chapter on the art of coloring, which may be found in the latter part of this volume.

To Preserve Daguerreotypes they must be well sealed and secured in a case, or frame. These, of course, are selected according to the taste of the customer, the principal requisite being good glass. Most Daguerreotypists prefer the white French plate glass—and many think,

very erroneously, that none is good unless it is thick—
but the great desideratum is clearness and freedom from
blisters; even glass a little tinged with green or yellow
is to be preferred to the French plate when cloudy or
blistered, and there is very little of it comes to this mar-
ket that is not so. It is to be hoped that some of our
glass factories will manage to manufacture an article ex-
pressly for daguerreotypes ; and I would recommend them
to do so, for they would find it quite an item of profit
annually.

Before enclosing the picture in the case you should be
careful to wipe the glass perfectly clean, and blow from
the picture any particles of dust which may have fallen
upon it. Then take strips of sticking paper, about half
or three quarters of an inch wide, and firmly and neatly
secure it to the glass, having first placed a " mat" be-
tween them to prevent the plate being scratched by the
glass.

To make Sealing Paper.—Dissolve one ounce of
gum arabic, and a quarter of an ounce of gum tragicanth
in a pint of water; then add a teaspoonful of benzoïn.
Spread this evenly on one side of good stout tissue paper ;
let it dry, and then cut it up in stripes, about half or
three quarters of an inch wide, for use. If it becomes
too soft for summer use, add gum arabic; if too hard and
cracking, add benzoin or gum tragicanth ; if it gets too
thick, add water.

Colored Daguerreotypes on Copper.—To effect this,
take a polished plate of copper and expose it to the va-
por of iodine, or bromine, or the two substances com-
bined; or either of them in combination with chlorine.
This gives a sensitive coating to the surface of the plate,
which may then be submitted to the action of light in the

camera. After remaining a sufficient time in the camera, the plate is taken out and exposed to the vapor of sulphuretted hydrogen. This vapor produces various colors on the plate, according to the intensity with which the light has acted on the different parts; consequently a colored photographic picture is obtained. No further process is necessary as exposure to light does not effect the picture.

By this process we have an advantage over the silvered plate, both iu economy, and in the production of the picture in colors.

INSTANTANTANEOUS PICTURES BY MEANS OF GALVANISM. —It will be seen by the following valuable communication that galvanism can be successfully applied in producing pictures instantly; a process of great importance in securing the likeness of a child, or in taking views of animated nature. Colonel Whitney informs me that he once took a view of the steeple of the St. Louis Court House *after sundown* by this means, and also secured the image of a man in the act of stepping into a store, and before he had time to place his foot, raised for that purpose, on the door step. Mr. Whitney is well known as the talented editor of the Sunday Morning news.

New York, January 16, 1849.

Mr. H. H. SNELLING.

Dear Sir,—As you are about publishing a history of the Daguerreotype, and request a description of my mode of taking pictures instantaneously by the aid of galvanism, I comply with great pleasure.

In the year 1841, while practicing the art in St. Louis, Mo., I was at times, during the summer, much troubled with the electric influence of the atmosphere, especially

on the approach of a thunder-storm. At such times I found the coating of my plates much more sensitive than when the atmosphere was comparatively free from the electric fluid, and the effect was so irregular that no calculation could counteract the difficulty. This satisfied me that electricity was in some measure an important agent in the chemical process, and it occurred to me that the element might be turned to advantage. I determined, therefore, to enter on a series of experiments to test my theory. Finding it impossible to obtain an electric machine, and unwilling to abandon the examination, it occurred to me, that the galvanic influence might answer the same purpose. I therefore proceeded to make a galvanic battery in the followsng simple manner. I obtained a piece of zinc about two inches long, one inch wide, and an eighth of an inch thick. On this I soldered a narrow strip of copper, about six inches long, the soldered end laid on one side of the zinc, and extending its whole length. The battery was completed by placing the zinc in a glass tumbler, two-thirds full of dilute sulphuric acid, strong enough to produce a free action of the metals. The upper end of the copper slip extending above the tumbler was sharpened to a point, and bent a little over the glass.

The method of using, was thus :—After preparing the plate in the usual manner and placing it in the camera, in such manner as to expose the back of the plate to view, the battery was prepared by placing the zinc in the acid, and as soon as the galvanic fluid began to traverse (as could be known by the effervessence of the acid, operating on the zinc and copper) the cap of the camera was removed, and the plate exposed to the sitter ; at the same instant the point of the battery was brought quickly

against the back of the plate, and the cap replaced in-instantly. If the plate is exposed more than an instant after the contact the picture will generally be found solarized. By this process 1 have taken pictures of persons in the act of walking, and in taking the pictures of infants and young children I found it very useful.

<div style="text-align: right">Very respectfully yours,

Thomas R. Whitney.</div>

CHAP. VII

PAPER DAGUERREOTYPES.—ETCHING DAGUERREOTYPES.

Mr. Hunt describes a process, discovered by himself by which the Daguerrean art may be applied to paper. His description is as follows :—

" Placing the paper on some hard body, wash it over on one side—by means of a very soft camel's hair pencil—with a solution of sixty grains of bromide of potassium, in two fluid ounces of distilled water, and then dry it quickly by the fire. Being dry, it is again washed over with the same solution, and dried as before. A solution of nitrate of silver—one hundred grains to an ounce of distilled water—is to be applied over the same surface, and the paper quickly dried in the dark. In this state the papers may be kept for use.

" When they are required, the above solution of silver is to be plentifully applied, and the paper placed wet in the camera, the greatest care being taken that no day light—not even the faintest gleam—falls upon it until the moment when you are prepared, by removing the dark slide, to permit the light, radiating from the object you wish to copy, to act in producing the picture. After a few seconds the light must be again shut off, and the camera removed into a dark room." The necessity of removing the camera is now avoided by the use of the dark slide, already described, covering the picture in the holder, which alone may be removed.—*Amer. Aut.*

" It will be found by taking the paper from the holder, that there is but a very faint outline—if any—yet visible. Place it aside, in perfect darkness until quite dry ; then place it in the mercurial vapor box (meaning bath) and apply a very gentle heat to the bottom. The moment the mercury vaporizes, the picture will begin to develope itself. The spirit lamp must now be removed for a short time, and when the action of the mercury appears to cease, it is to be very carefully applied again, until a well defined picture is visible. The vaporization must then be suddenly stopped, and the photograph removed from the box. The drawing will then be very beautiful and distinct ; but much detail is still clouded, for the developement of which it is only necessary to place it in the dark and suffer it to remain undisturbed for some hours. There is now an inexpressible charm about the pictures, equaling the delicate beauty of the daguerreotype ; but being very susceptible of change, it must be viewed by the light of a taper only. The nitrate of silver must now be removed from the paper, by well washing it in soft water, to which a small quantity ef salt has been added, and it should afterwards be soaked in water only. When the picture has been dried, wash it quickly over with a soft brush dipped in a warm solution of hyposulphite of soda, and then wash it for some time in distilled water, in order that all the hyposulphite may be removed. The drawing is now fixed and we may use it to procure positive copies, (the original being termed a negative,) many of which may be taken from one original."

" The action of light on this preparation, does indeed appear to be instantaneous. The exquisite delicacy of this preparation may be imagined, when I state that in

five seconds in the camera, I have, during sunshine, obtained perfect pictures, and that when the sky is overcast, *one minute* is quite sufficient to produce a most decided effect."

" This very beautiful process is not without its difficulties; and the author cannot promise that, even with the closest attention to the above directions, annoying failures will not occur. It often happens that some accidental circumstance—generally a projecting film or a little dust—will occasion the mercurial vapor to act with great energy on one part of the paper, and blacken it before the other portions are at all effected. Again, the mercury will sometimes accumulate along the lines made by the brush, and give a streaky appearance to the picture, although these lines are not at all evident before the mercurial vapor was applied. (A brush sufficiently large —and they may be easily obtained—will, in a measure, prevent this difficulty.—*Amer Au.*) I have stated that the paper should be placed wet in the camera ; the same paper may be used dry, which often is a great convenience. When in the dry state a little longer exposure is required ; and instead of taking a picture in four or five seconds, two or three minutes are necessary."

The durability of daguerreotypes has been, and is still, doubted by many, but experiment has proved that they are more permanent than oil paintings or engravings.

ETCHING DAGUERREOTYPES.—There are several methods of accomplishing this object; discovered and applied by different individuals.

The first process was published at Vienna by Dr. Berres, and consisted in covering the plate with the mucilage of gum arabic, and then immersing the plate in nitric acid of different strengths.

Mr. Figeau, of whom I have already spoken, likewise discovered a process for the engraving of Daguerreotypes; and founded on the belief that the lights of a Daguerreotype plate consists of unaltered silver, while the dark or shadows consists of mercury or an amalgam of mercury with silver. He finds that a compound acid, consisting of a mixture of nitric, nitrous, and muriatic acids, or of nitric mixed with nitrate of potass and common salt, has the property of attaching the silver in presence of the mercury without acting upon the latter. Bi-chloride of copper answers the purpose also, but less completely.

" When the clean surface of a Daguerreotype plate is exposed to the action of this menstruum, particularly if warm, the white parts, or lights are not altered, but the dark parts are attacked, and chloride of silver is formed, of which an insoluable coating is soon deposited, and the action of the acid soon ceases. This coat of chloride of silver is removed by a solution of ammonia, and then the acid applied again, and so on, until the depth of *biting in* is sufficient. However, it is not possible, by repeating this process, to get a sufficient force of impression; a second operation is required, in order to obtain such a depth as will hold the ink, to give a dark impression; for this purpose the whole plate is covered with drying oil; this is cleared off with the hand, exactly in the way a copper plate printer cleans his plate. The oil is thus left in the *sinkings*, or dark *bitten in* parts only. The whole plate is now placed in a suitable apparatus, and the lights or prominent parts of the face are gilt by the electrotype process. The whole surface is now touched with what the French engravers call the " Resin Grain," (*grain de resine*), a species of partial stopping

out, and it is at once bitten in to a sufficient depth with nitric acid, the gilding preserving the lights from all action of the acid. The resin grain gives a surface to the corroded parts suitable for holding the ink, and the plate is now finished and fit to give impressions resembling aquatint. But as silver is so soft a metal that the surface of the plate might be expected to wear rapidly, the discoverer proposes to shield it by depositing over its whole surface a very thin coat of copper by the electrotype process; which when worn may be removed at pleasure down to the surface of the noble metal beneath, and again a fresh coat of copper deposited; and so an unlimited number of impressions obtained without injuring the plate itself."

If, as has been asserted, steel may be rendered sufficiently sensitive, to take photographic impressions, to what a revolution will the art of engraving be subject by the discovery of this process.

CHAP. VIII.

We shall now proceed to describe the various processes for Photogenic drawing on paper; first, however, impressing on the mind of the experimenter, the necessity which exists for extreme care in every stage of the manipulation. In this portion of my work I am entirely indebted to the works of Professors Hunt, Fisher and others.

I. APPARATUS AND MATERIALS.—*Paper.*—The principal difficulty to be contended with in using paper, is the different power of imbibition which we often find possessed in the same sheet, owing to trifling inequalities in its texture. This is, to a certain extent, to be overcome by a careful examination of each sheet, by the light of a candle or lamp at night, or in the dark. By extending each sheet between the light and the eye, and slowly moving it up and down, and from left to right, the variations in its texture will be seen by the different quantities of light which pass through it in different parts; and it is always the safest course to reject every sheet in which inequalities exist. Paper sometimes contains minute portions of thread, black or brown specks, and other imperfections, all of which materially interfere with the process. Some paper has an artificial substance given to it by sulphate of lime (Plaster of Paris); this defect only exists, however, in the cheaper sorts of demy, and therefore can be easily avoided. In all cases such paper

should be rejected, as no really sensitive material can be obtained with it. Paper-makers, as is well known, often affix their name to one half the sheet; this moiety should also be placed aside, as the letters must frequently come out with annoying distinctness. Well sized paper is by no means objectionable, indeed, is rather to be preferred, since the size tends to exalt the sensitive powers of the silver. The principal thing to be avoided, is the absorption of the sensitive solution into the pores; and it must be evident that this desideratum cannot be obtained by unsized paper. Taking all things into consideration, the paper known as *satin post* would appear to be preferable, although the precautions already recommended should be taken in its selection.

Brushes.—The necessary solutions are to be laid upon the paper by brushes. Some persons pass the paper over the surface of the solutions, thus licking up, as it were, a portion of the fluid; but this method is apt to give an uneven surface; it also rapidly spoils the solutions. At all events, the brush is the most ready and the most effectual means.

Distilled Water.—All the water used, both for mixing the solutions, washing the paper, or cleaning the brushes, must be distilled, to obtain good results, for reasons before specified.

Blotting Paper.—In many instances, the prepared paper requires to be lightly dried with bibulous paper. The best description is the white sort. In each stage of the preparation distinct portions of bibulous paper must be used. If these be kept seperate and marked, they can be again employed for the same stage; but it would not do, for example, to dry the finished picture in the same folds in which the sensitive paper had been pressed. A

very convenient method is to have two or three quarto size books of bibulous paper, one for each seperate process.

Nitrate of Silver.—In the practice of the photographic art, much depends on the nitrate of silver. Care should be taken to procure the best; the crystalized salt is most suitable for the purpose While in the form of crystal it is not injured by exposure to light, but the bottles containing the solutions of this salt should at all times be kept wrapped in dark paper, and excluded from daylight.

II. DIFFERENT METHODS OF PREPARING THE PAPER. —*Preparation of the Paper.*—Dip the paper to be prepared into a weak solution of common salt. The solution should not be saturated, but six or eight times diluted with water. When perfectly moistened, wipe it dry with a towel, or press it between bibulous paper, by which operation the salt is uniformly dispersed through its substance. Then brush over it, on one side only, a solution of nitrate of silver. The strength of this solution must vary according to the color and sensitiveness required. Mr. Talbot recommends about fifty grains of the salt to an ounce of distilled water. Some advise twenty grains only, while others say eighty grains to the ounce. When dried in a dark room, the paper is fit for use. To render this paper still more sensitive, it must again be washed with salt and water, and afterwards with the same solution of nitrate of silver, drying it between times. This paper, if carefully made, is very useful for all ordinary photographic purposes. For example, nothing can be more perfect than the images it gives of leaves and flowers, especially with a summer's sun; the light, passing through the leaves, delineates every ramification of

their fibres. In conducting this operation, however, it will be found that the results are sometimes more and sometimes less satisfactory, in consequence of small and accidental variations in the proportions employed. It happens sometimes that the chloride of silver formed on the surface of the paper is disposed to blacken of itself, without any exposure to light. This shows that the attempt to give it sensibility has been carried too far. The object is, to approach as nearly to this condition as possible without reaching it; so that the preparation may be in a state ready to yield to the slightest extraneous force, such as the feeblest effect of light.

Cooper's Method.—Soak the paper in a boiling hot solution of chlorate of potash (the strength matters not) for a few minutes; then take it out, dry it, and wet it with a brush, on one side only, dipped in a solution of nitrate of silver, sixty grains to an ounce of distilled water, or, if not required to be so sensitive, thirty grains to the ounce will do. This paper possesses a great advantage over any other, for the image can be fixed by mere washing. It is, however, very apt to become discolored even in the washing, or shortly afterwards, and is, besides, not so sensitive, nor does it become so dark as that made according to Mr. Talbot's method.

Daguerre's Method.—Immerse the paper in hydrochloric (or as it is more commonly called, muriatic) ether, which has been kept sufficiently long to become acid; the paper is then carefully and completely dried, as this is essential to its proper preparation. It is then dipped into a solution of nitrate of silver, and dried without artificial heat in a room from which every ray of light is carefully excluded. By this process it acquires a very remarkable facility in being blackened on a very slight ex-

posure to light, even when the latter is by no means in tense. The paper, however, rapidly loses its extreme sensitiveness to light, and finally becomes no more impressionable by the solar beams than common nitrate paper.

Bromide Paper.—Of all common photographic paper, the best, because the least troublesome in making, and the most satisfactory in result, is that which is termed bromine paper, and which is thus prepared :—Dissolve one hundred grains of bromide of potassium in one ounce of distilled water, and soak the paper in this solution. Take off the superfluous moisture, by means of your bibulous paper, and when nearly dry, brush it over on one side only, with a solution of one hundred grains of nitrate of silver to an ounce of distilled water. The paper should then be dried in a dark room, and, if required to be very sensitive, should a second time be brushed over with the nitrate of silver solution.

In preparing the papers mentioned above, there are two circumstances which require particular attention. In the first place, it is necessary to mark the paper on the side spread with the solutions of nitrate of silver, near one of the extreme corners. This answers two purposes : in the first place it serves to inform the experimentalist of the sensitive surface ; and secondly, it will be a guide as to which portion of the papers has been handled during the application of the solution, as the impress of the fingers will probably come out upon the photograph. The second caution is, that the application of the sensitive solution (nitrate of silver,) and the subsequent drying of the paper, must be always conducted in a perfectly dark room, the light of a candle alone being used.

III. PHOTOGENIC PROCESS ON PAPER.—*Method.*—
The simplest mode is to procure a flat board and
a square of glass, larger in size than the object in-
tended to be copied. On the board place the photogra-

Fig. 29.

phic paper with the prepared side upwards, and upon it
the object to be copied; over both lay the glass and se-
cure them so that they are in close connection by means
of binding screws or clamps, similar to g. g. fig. 29.
Should the object to be copied be of unequal thickness,
such as a leaf, grass, &c., it will be necessary to place
on the board, first, a soft cushion, which may be made
of a piece of fine flannel and cotton wool. By this
means the object is brought into closer contact with the
paper, which is of great consequence, and adds mate-
rially to the clearness of the copy. The paper is now
exposed to diffused daylight, or, still better, to the di-
rect rays of the sun, when that part of the paper not
covered by the object will become tinged with a violet
color, and if the paper be well prepared, it will in a
short time pass to a deep brown or bronze color. It
must then be removed, as no advantage will be obtained

by keeping it longer exposed ; on the contrary, the delicate parts yet uncolored will become in some degree affected. The photogenic paper will now show a more or less white and distinct representation of the object. The apparatus figured at 29 consists of a wooden frame similar to a picture frame; a piece of plate glass is fixed in front; and it is provided with a sliding cover of wood, c., which is removed when the paper is ready to be exposed to the action of the light. The back, d., which is furnished with a cushion, as just described, is made to remove for the purpose of introducing the object to be copied, and upon it the prepared paper ; the back is then replaced, and, by aid of the cross piece and screw, e., the whole is brought into close contact with the glass.

The objects best delineated on these photographic papers, are lace, feathers, dried plants, particularly the ferns, sea-weeds and the light grasses, impressions of copper plate and wood engravings, particularly if they have considerable contrast of light and shade—(these should be placed with the face downwards, having been previously prepared as hereafter directed)—paintings on glass, etchings, &c.

To fix the Drawings.—Mr. Talbot recommends that the drawings should be dipped in salt and water, and in many instances this method will succeed, but at times it is equally unsuccessful. Iodide of potassium, or, as it is frequently called, hydriodate of potash, dissolved in water, and very much diluted, (twenty-five grains to one ounce of water,) is a more useful preparation to wash the drawings with ; it must be used very weak or it will not dissolve the unchanged muriate only, as is intended, but the black oxide also, and the drawing be thereby spoiled.

But the most certain material to be used is the hypo-
sulphite of soda. One ounce of this salt should be dis-
solved in about a pint of distilled water. Having pre-
viously washed the drawing in a little lukewarm water,
which of itself removes a large portion of the muriate of
silver which is to be got rid of, it should be dipped once
or twice in the hyposulphite solution. By this operation
the muriate which lies upon the lighter parts will be-
come so altered in its nature as to be unchanged by light,
while the rest remains dark as before.

It will be evident from the nature of the process, that
the lights and shadows of an object are reversed. That
which is originally opaque will intercept the light, and
consequently those parts of the photogenic paper will be
least influenced by light, while any part of the object
which is transparent, by admitting the light through it,
will suffer the effect to be greater or less in exact propor-
tion to its degree of transparency. The object wholly
intercepting the light will show a white impression ; in
selecting, for example, a butterfly for an object, the in-
sect, being more or less transparent, leaves a propor-
tionate gradation of light and shade, the most opaque
parts showing the whitest. It may be said, therefore,
that this is not natural, and in order to obtain a true pic-
ture—or, as it is termed, a positive picture—we must
place our first acquired photograph upon a second piece
of photogenic paper. Before we do this, however, we
must render our photograph transparent, otherwise the
opacity of the paper will mar our efforts.

To accomplish this object, the back of the paper con-
taining the *negative*, or first acquired photograph, should
be covered with white or virgin wax. This may be done
by scraping the wax upon the paper, and then, after

placing it between two other pieces of paper, passing a heated iron over it. The picture, being thus rendered transparent, should now be applied to a second piece of photogenic paper, and exposed, in the manner before directed, either to diffused day-light or to the direct rays of the sun. The light will now penetrate the white parts, and the second photograph be the reverse of the first, or a true picture of the original.

Instead of wax, boiled linseed oil—it must be the best and most transparent kind—may be used. The back of the negative photograph should be smeared with the oil, and then placed between sheets of bibulous paper. When dry the paper is highly transparent.

IV. APPLICATION OF PHOTOGENIC DRAWING.—This method of photogenic drawing may be applied to many useful purposes, such as the copying of paintings on glass by the light thrown through them on the prepared paper—Imitations of etchings, which may be accomplished by covering a piece of glass with a thick coat of white oil paint; when dry, with the point of a needle, lines or scratches are to be made through the white lead ground, so as to lay the glass bare; then place the glass upon a piece of prepared paper, and expose it to the light. Of course every line will be represented beneath of a black color, and thus an imitation etching will be produced. It is also applicable to the delineation of microscopic objects, architecture, seulpture, landscapes and external nature.

A novel application of this art has been recently suggested, which would doubtless prove useful in very many instances. By rendering the wood used for engravings sensitive to light, impressions may be at once made thereon, without the aid of the artist's pencil. The pre-

paration of the wood is simply as follows:—Place its face or smooth side downwards, in a plate containing twenty grains of common salt dissolved in an ounce of water; here let it remain for five minutes, take it out and dry it; then place it again face downwards in another plate containing sixty grains of nitrate of silver to an ounce of water; here let it rest one minute, when taken out and dried in the dark it will be fit for use, and will become, on exposure to the light, of a fine brown color. Should it be required more sensitive, it must be immersed in each solution a second time, for a few seconds only. It will now be very soon effected by a very diffused light.

This process may be useful to carvers and wood engravers; not only to those who cut the fine objects of artistical design, but still more to those who cut patterns and blocks for lace, muslin, calico-printing, paper hangings, etc., as by this means the errors, expense and time of the draughtsman may be wholly saved, and in a minute or two the most elaborate picture or design, or the most complicated machinery, be delineated with the utmost truth and clearness.

CHAP. IX.

The materials and apparatus necessary for the Calotype process are—

Two or Three Shallow Dishes, for holding distilled water, iodide, potassium, &c.—the same water never being used for two different operations.

White Bibulous Paper.

Photogenic Camera—Fig. 9.

Pressure Frame—Fig 29.

Paper, of the very best quality—directions for the choice of which have been already given.

A Screen of Yellow Glass.

Camels' or Badgers' hair Brushes:—A seperate one being kept for each wash and solution, and which should be thoroughly cleansed immediately after using in distilled water. That used for the gallo-nitrate is soon destroyed, owing to the rapid decomposition of that preparation.

A Graduated Measure.

Three or Four Flat Boards, to which the paper may be fixed with drawing pins.

A Hot Water Drying Apparatus, for drying the paper will also be found useful.

In preparing the Calotype paper, it is necessary to be extremely careful, not only to prevent the daylight from

impringing upon it, but also to exclude, if possible, the strong glare of the candle or lamp. This may be effected by using a shade of yellow glass or gauze, which must be placed around the light. Light passing through such a medium will scarcely affect the sensitive compounds, the yellow glass intercepting the chemical rays.

Preparation of the Iodized Paper.—Dissolve one hundred grains of crystalized nitrate of silver in six ounces of distilled water, and having fixed the paper to one of the boards, brush it over with a soft brush on one side only with this solution, a mark being placed on that side whereby it may be known. When nearly dry dip it into a solution of iodide of potassium, containing five hundred grains of that salt dissolved in a pint of water. When perfectly saturated with this solution, it should be washed in distilled water, drained and allowed to dry. This is the first part of the process, and the paper so prepared is called *iodized paper*. It should be kept in a port-folio or drawer until required : with this care it may be preserved for any length of time without spoiling or undergoing any change.

Mr. Cundell finds a stronger solution of nitrate of silver preferable, and employs thirty grains to the ounce of distilled water : he also adds fifty grains of common salt to the iodide of potassium, which he applies to the marked side of the paper only. This is the first process.

Preparation of the paper for the Camera.—The second process consists in applying to the above a solution which has been named by Mr. Talbot the "Gallo-Nitrate of Silver;" it is prepared in the following manner: Dissolve one hundred grains of crystalized nitrate of silver in two ounces of distilled water, to which is added two

and two-third drachms of strong acetic acid. This so-
lution should be kept in a bottle carefully excluded from
the light. Now, make a solution of gallic acid in cold
distilled water : the quantity dissolved is very small.
When it is required to take a picture, the two liquids
above described should be mixed together in equal quan-
tities ; but as it speedily undergoe decomposition, and
will not keep good for many minutes, only just sufficient
for the time should be prepared, and that used without
delay. It is also well not to make much of the gallic
acid solution, as it will not keep for more than a few
days without spoiling. A sheet of the iodized paper
should be washed over with a brush with this mixed so-
lution, care being taken that it be applied to the marked
side. This operation must be performed by candle light.
Let the paper rest half a minute, then dip it into one of
the dishes of water, passing it beneath the surface seve-
ral times ; it is now allowed to drain, and dried by
placing its marked side upwards, on the drying appara-
tus. It is better not to touch the surface with bibulous
paper. It is now highly sensitive, and ready to receive
the impression. In practice it is found better and more
economical not to mix the nitrate of silver and gallic
acid, but only to brush the paper with the solution of the
nitrate.

Mr. Talbot has recently proposed some modifications in
his method of preparing the calotype paper. The paper
is first iodized in the usual way ; it is then washed over
with a saturated solution of gallic acid in distilled water
and dried. Thus prepared he calls it the io-gallic paper :
it will remain good for a considerable time if kept in a
press or portfolio. When required for use, it is washed
with a solution of nitrate of silver (fifty grains to the

ounce of distilled water), and it is then fit for the ca-
mera.

Exposure in the Camera.—The calotype paper thus
prepared possesses a very high degree of sensibility when
exposed to light, and we are thus provided with a me-
dium by which, with the aid of the photogenic camera,
we may effectually copy views from nature, figures,
buildings, and even take portraits from the shadows
thrown on the paper by the living face. The paper may
be used somewhat damp. The best plan for fixing it in
the camera is to place it between a piece of plate glass
and some other material with a flat surface, as a piece of
smooth slate or an iron plate, which latter, if made
warm, renders the paper more sensitive, and consequently
the picture is obtained more rapidly.

Time of Exposure.—With regard to the time which
should be allowed for the paper to remain in the camera,
no direct rules can be laid down; this will depend alto-
gether upon the nature of the object to be copied, and
the light which prevails. All that can be said is, that
the time necessary for forming a good picture varies from
thirty seconds to five minutes, and it will be naturally
the first object of the operator to gain by experience this
important knowledge.

Bringing Out the Picture.—The paper when taken
from the camera, which should be done so as to exclude
every ray of light—and here the dark slide of the ca-
mera plate holder becomes of great use—bears no resem-
blance to the picture which in reality is formed. The
impression is latent and invisible, and its existence would
not be suspected by any one not acquainted with the
process by previous experiment. The method of bring-
ing out the image is very simple. It consists in wash-

ing the paper with the *gallo-nitrate of silver*, prepared in the way already described, and then warming it gently, being careful at the same time not to let any portion become perfectly dry. In a few seconds the part of the paper upon which the light has acted will begin to darken, and finally grow entirely black, while the other parts retain their original color. Even a weak impression may be brought out by again washing the paper in the gallo-nitrate, and once more gently warming it. When the paper is quite black, as is generally the case, it is a highly curious and beautiful phenomenon to witness the commencement of the picture, first tracing out the stronger outlines, and then gradually filling up all the numerous and complicated details. The artist should watch the picture as it developes itself, and when in his judgment it has attained the greatest degree of strength and clearness, he shall stop further proceedings by washing it with the fixing liquid. Here again the mixed solution need not be used, but the picture simply brushed over with the gallic acid.

The Fixing Process.—In order to fix the picture thus obtained, first dip it into water; then partly dry it with bibulous paper, and wash it with a solution of bromide of potassium—containing one hundred grains of that salt dissolved in eight or ten ounces of distilled water. The picture is again washed with distilled water, and then finally dried. Instead of bromide of potassium, a solution of hyposulphite of soda, as before directed, may be used with equal advantage.

The original calotype picture, like the photographic one described in the last chapter, is negative, that is to say, it has its lights and shades reversed, giving the whole an appearance not conformable to nature. But it

is easy from this picture to obtain another which shall be conformable to nature; viz., in which the lights shall be represented by lights, and the shades by shades. It is only necessary to take a sheet of photographic paper (the bromide paper is the best), and place it in contact with a calotype picture previously rendered transparent by wax or oil as before directed. Fix it in the frame, *Fig.* 29, expose it in the sunshine for a short time, and an image or copy will be formed on the photogenic paper. The calotype paper itself may be used to take the second, or positive, picture, but this Mr. Talbot does not recommend, for although it takes a much longer time to take a copy on the photogenic paper, yet the tints of such copy are generally more harmonious and agreeable. After a calotype picture has furnished a number of copies it sometimes grows faint, and the subsequent copies are inferior. This may be prevented by means of a process which revives the strength of the calotype pictures. In order to do this, it is only nesessary to wash them by candle-light with gallo-nitrate of silver, and then warm them. This causes all the shades of the picture to darken considerably, while the white parts are unaffected. After this the picture is of course to be fixed a second time. It will then yield a second series of copies, and, in this way, a great number may frequently be made.

The calotype pictures when prepared as we have stated, possess a yellowish tint, which impedes the process of taking copies from them. In order to remedy this defect, Mr. Talbot has devised the following method. The calotype picture is plunged into a solution consisting of hyposulphite of soda dissolved in about ten times its weight of water, and heated nearly to the boiling point. The picture should remain in about ten minutes; it must then

be removed, washed and dried. By this process the picture is rendered more transparent, and its lights become whiter. It is also rendered exceedingly permanent. After this process the picture may be waxed, and thus its transparency increased. This process is applicable to all photographic papers prepared with solutions of silver.

Having thus fully, and it is hoped clearly, considered the process, it may be necessary before dismissing the calotype from notice, to add one or two remarks from the observations and labors of some who have experimented in this art. Dr. Ryan in his lectures before the Royal Polytechnic Institution, has observed, that in the iodizing process the sensitiveness of the paper is materially injured by keeping it too long in the solution of iodide of potassium, owing to the newly formed iodide of silver being so exceedingly solvable in excess of iodide of potassium as in a few minutes to be completely removed. The paper should be dipped in the solution and instantly removed. There is another point, too, in the preparation of the iodized paper in which suggestions for a slight deviation from Mr. Talbot's plan have been made. In the first instance, it is recommended that the paper be brushed over with the iodide of potassium, instead of the nitrate of silver, transposing, in fact, the application of the first two solutions. The paper, having been brushed over with the iodide of potassium in solution, is washed in distilled water and dried. It is then brushed over with nitrate of silver, and after drying is dipped for a moment in a fresh solution of iodide of potassium of only one-fourth the strength of the first, that is to say, one hundred and twenty-five grains of the salt to a pint of water. After this it is again washed and dried. The advantage derived from this method, is a more sensitive paper, and

a more even distribution of the compounds over the sur-
face.

Another deviation from Mr. Talbot's method has been
suggested, as follows:

Brush the paper over with a solution of one hundred
grains of nitrate of silver to an ounce of water. When
nearly, but not quite, dry, dip it into a solution of twenty-
five grains of iodide of potassium to one ounce of distilled
water, drain it, wash it in distilled water and again drain
it. Now brush it over with aceto-nitrate of silver, made
by dissolving fifty grains of nitrate of silver in one ounce
of distilled water, to which is added one sixth of its vo-
lume of strong acetic acid. Dry it with bibulous paper,
and it is ready for receiving the image. When the im-
pression has been received, which will require from one
to five minutes according to the state of the weather, it
must be washed with a saturated solution of gallic acid
to which a few drops of the aceto-nitrate of silver, made
as above, have been added. The image will thus be
gradually brought out, and may be fixed with hyposul-
phite of soda. To obtain the positive picture, paper
must be used brushed over with an ammonio-nitrate of
silver, made thus : forty grains of nitrate of silver is to be
dissolved in one ounce of distilled water, and liquid am-
monia cautiously added till it re-dissolves the precipitate.

A pleasing effect may be given to calotype, or indeed
to all photographic pictures, by waxing them at the back,
and mounting them on white paper, or if colored paper
be used, various beautiful tones of color are produced

POSITIVE CALOTYPE.

At a meeting of the British Association, Professor
Grove described a process by which positive calotype

pictures could be directly obtained ; and thus the neces-
sity to transfer by which the imperfections of the paper
are snown, and which is moreover a troublesome and
tedious process, is avoided. As light favors most chem-
ical actions, Mr. Grove was led to believe that a paper
darkened by the sun (which darkening is supposed to re-
sult from the precipitation of silver) might be bleached
by using a solvent which would not attack the silver in
the dark, but would do so in the light. The plan found
to be the most successful is as follows : ordinary calotype
paper is darkened till it assumes a deep brown color,
almost amounting to black ; it is then redipped into the
ordinary solution of iodide of potassium, and dried. When
required for use it is drawn over dilute nitric acid—one part
acid to two and a half parts water. In this state, those
parts exposed to the light are rapidly bleached, while the
parts not exposed remain unchanged. It is fixed by wash-
ing in water, and subsequently in hyposulphite of soda,
or bromide of potassium.

Mr. Grove also describes a process for converting
a negative calotype into a positive one, which promises,
when carried out, to be of great utility.

Let an ordinary calotype image or portrait be taken in
the camera, and developed by gallic acid ; then drawn
over iodide of potassium and dilute nitric acid and ex-
posed to full sunshine ; while bleaching the dark parts,
the light is redarkening the newly precipitated iodide in
the lighter portions and thus the negative picture is con-
verted into a positive one.

The calotype process has been applied to the art of
printing, in England, but it possesses no advantages
whatever over the method, with type, now so gloriously
brought to perfection ; and I can hardly think it will

tography with all the distintness and clearness of calo-
type. This preparation is as follows.
ever be made of any utility. For the benefit of the cu-
rious, however, I will give Mr. Talbot's method.

Some pages of letter-press are taken printed on one
side only; and waxed, to render them more transparent;
the letters are then cut out and sorted. To compose a
new page lines are ruled on a sheet of white paper, and
the words are formed by fixing the seperate letters in their
proper order. The page being ready, a negative photo-
graph is produced from it, from which the requisite num-
ber of positive photogenic copies may be obtained.

Another method, which requires the use of the came-
ra, consists in employing large letters painted on rectan-
gular pieces of wood, colored white. These are arranged
in lines on a tablet or board, by slipping them into grooves
which keep them steady and upright, thus forming a
page on an enlarged scale. It is now placed before a
camera, and a reduced image of it of the required size is
thrown upon the sensitive paper. The adjustments must
be kept invariable, so that the consecutive pages may not
vary from one another in the size of the type. Mr. Tal-
bot has patented his process, but what benefit he expects
to derive from it, I am at a loss to determine.

Enlarged copies of calotype or Daguerreotype portraits
may be obtained by throwing magnified images of them,
by means of lenses, upon calotype paper.

THE CHRYSOTYPE.

A modification of Mr. Talbot's process, to which the
name of Chrysotype was given by its discoverer, Sir
John Herschel, was communicated in June 1843 to the
Royal Society, by that distinguished philosopher. This
modification would appear to unite the simplicity of pho-

The paper is to be washed in a solution of ammonio-citrate of iron; it must then be dried, and subsequently brushed over with a solution of the ferro-sesquicyanuret of potassium. This paper, when dried in a perfectly dark room, is ready for use in the same manner as if otherwise prepared, the image being subsequently brought out by any neutral solution of gold. Such was the first declaration of his discovery, but he has since found that a neutral solution of silver is equally useful in bringing out the picture. Photographic pictures taken on this paper are distinguished by a clearness of outline foreign to all other methods.

CHAP. X.

CYANOTYPE--ENERGIATYPE—CHROMATYPE—ANTHOTYPE—
AMPHITYPE AND "CRAYON DAGUERREOTYPE."

THE several processes enumerated at the head of this chapter, are all discoveries of English philosophers, with the exception of the third and last named. Anthotype was first attempted by M. Ponton a French savan, although it was reserved to Mr. Hunt to bring the process to its present state. The "Crayon Daguerreotype" is an improvement made by J. A Whipple, Esq., of Boston

I. CYANOTYPE ;

So called from the circumstance of cyanogen in its combinations with iron performing a leading part in the process. It was discovered by Sir John Herschel. The process is a simple one, and the resulting pictures are blue.

Brush the paper over with a solution of the ammonio-citrate of iron. This solution should be sufficiently strong to resemble sherry wine in color. Expose the paper in the usual way, and pass over it very sparingly and evenly a wash of the common yellow ferro-cyanate of potass. As soon as the liquid is applied, the negative picture vanishes, and is replaced by a positive one, of a violet blue color, on a greenish yellow ground, which at a certain time possesses a high degree of sharpness, and singular beauty of tint.

A curious process was discovered by Sir John Herschel, by which dormant pictures are produced capable of developement by the breath, or by keeping in a moist atmosphere. It is as follows.

If nitrate of silver, specific gravity 1.200 be added to ferro-tartaric acid, specific gravity 1.023, a precipitate falls, which is in a great measure redissolved by a gentle heat, leaving a black sediment, which, being cleared by subsidence, a liquid of a pale yellow color is obtained, in which the further addition of the nitrate causes no turbidness. When the total quantity of the nitrated solution added amounts to about half the bulk of the ferro-tartaric acid, it is enough. The liquid so prepared does not alter if kept in the dark. Spread on paper, and exposed *wet* to the sunshine (partly shaded) for a few seconds, no impression seems to be made, but by degrees, although withdrawn from the action of light, it developes itself spontaneously, and at length becomes very intense. But if the paper be thoroughly dried in the dark, (in which state it is of a very pale greenish yellow color,) it possesses the singular property of receiving a dormant or invisible picture, to produce which from thirty to sixty seconds' exposure to sunshine is requisite. It should not be exposed too long, as not only is the ultimate effect less striking, but a picture begins to be *visibly* produced, which darkens spontaneously after it is withdrawn. But if the exposure be discontinued before this effect comes on, an invisible impression is the result, to develope which all that is necessary is to breathe upon it, when it immediately appears, and very speedily acquires an extraordinary intensity and sharpness, as if by magic. Instead of the breath, it may be subject to the regular action of aqueous vapor, by laying it in a blotting paper book, of

which some of the outer leaves on both sides 'have been dampened, or by holding over warm water.

II. ENERGIATYPE.

Under this title a process has been brought forward by Mr. Hunt. It consists of the application of a solution of succinic acid to paper, which is subsequently washed over with nitrate of silver. The image is then to be taken either in the camera or otherwise, as required, and is brought out by the application of the sulphate of iron in solution. Although this process has not come into general use, its exact description may be interesting to the general reader, and we therefore subjoin it.

The solution with which the paper is first washed is to be prepared as follows : succinic acid, two drachms ; common salt, five grains ; mucilage of gum arabic, half a fluid drachm; distilled water, one fluid drachm and a half. When the paper is nearly dry, it is to be brushed over with a solution of nitrate of silver, containing a drachm of the salt, to an ounce of distilled water. It is now ready for exposure in the camera. To bring out the dormant picture it is necessary to wash it with a mixture of a drachm of concentrated solution of the green sulphate of iron and two drachms and a half of mucilage of gum arabic.

Subsequently, however, it has been found that the sulphate of iron produces upon all the salts of silver effects quite as beautiful as in the succinate. On the iodide, bromide, acetate, and benzoate, the effects are far more pleasing and striking. When pictures are produced, or the dormant camera image brought out, by the agency of sulphate of iron, it is remarkable how rapidly the effect takes place. Engravings can be thus copied almost instantaneously, and camera views obtained in one

or two minutes on almost any preparation of silver. The common sulphate of copper solution has the same property.

III. CHROMATYPE.

Many efforts have been made to render chromatic acid an active agent in the production of photographs. M. Ponton used a paper saturated with bichromate of potash, and this was one of the earliest photogenic processes. M. Becquerel improved upon this process by sizing the paper with starch previous to the application of the bichromate of potash solution, which enabled him to convert the negative picture into a positive one, by the use of a solution of iodine, which combined with that portion of the starch on which the light had not acted. But by neither of these processes could clear and distinct pictures be formed. Mr. Hunt has, however, discovered a process which is so exceedingly simple, and the resulting pictures of so pleasing a character, that, although it is not sufficiently sensitive for use in the camera, it will be found of the greatest value for copying botanical specimens, engravings, or the like.

The paper to be prepared is washed over with a solution of sulphate of copper—about one drachm to an ounce of water—and partially dried; it is then washed with a moderately strong solution of bichromate of potash, and dried at a little distance from the fire. Paper thus prepared may be kept any length of time, in a portfolio, and are always ready for use.

When exposed to the sunshine for a time, varying with the intensity of the light, from five to fifteen or twenty minutes, the result is generally a negative picture. It is now to be washed over with a solution of nitrate of silver, which immediately produces a very beau-

tiful deep orange picture upon a light dim colored, or
sometimes perfectly white ground. This picture must
be quickly fixed, by being washed in pure water, and
dried. With regard to the strength of the solutions, it
is a remarkable fact, that, if saturated solutions be em-
ployed, a negative picture is first produced, but if the
solutions be three or four times their bulk of water, the
first action of the sun's rays darkens the picture, and
then a very bleaching effect follows, giving an exceed-
ingly faint positive picture, which is brought out with
great delicacy by the silver solution.

It is necessary that pure water should be used for the
fixing, as the presence of any muriate damages the pic-
ture, and here arises another pleasing variation of the
Chromatype. If the positive picture be placed in a very
weak solution of common salt the image slowly fades out,
leaving a faint negative outline. If it now be removed
from the saline solution, dried, and again exposed to
sunshine, a positive picture of a lilac color will be pro-
duced by a few minutes exposure. Several other of the
chromates may be used in this process, but none is so
successful as the chromate of copper.

IV. ANTHOTYPE.

The expressed juice, alcholic, or watery infusion of
flowers, or vegetable substances, may be made the media
of photogenic action. This fact was first discovered by
Sir John Herschel. We have already given a few ex-
amples of this in the third chapter.

Certain precautions are necessary in extracting the co-
loring matter of flowers. The petals of fresh flowers are
carefully selected, and crushed to a pulp in a marble mor-
tar, either alone or with the addition of a little alcohol,
and the juice expressed by squeezing the pulp in a clean

linen or cotton cloth. It is then to be spread upon paper with a flat brush, and dried in the air without artificial heat. If alcohol be not added, the application on paper must be performed immediately, as the air (even in a few minutes), irrecoverably changes or destroys their color. If alcohol be present this change is much retarded, and in some cases is entirely prevented.

Most flowers give out their coloring matter to alcohol or water. Some, however, refuse to do so, and require the addition of alkalies, others of acid, &c. Alcohol has, however, been found to enfeeble, and in many cases to discharge altogether these colors; but they are, in most cases, restored upon drying, when spread over paper. Papers tinged with vetegable colors must always be kept in the dark, and perfectly dry.

The color of a flower is by no means always, or usually, that which its expressed juice imparts to white paper. Sir John Herschel attributes these changes to the escape of carbonic acid in some cases; to a chemical alteration, depending upon the absorption of oxygen, in others; and again in others, especially where the expressed juice coagulates on standing, to a loss of vitality, or disorganization of the molecules. To secure an evenness of tint on paper, the following manipulation is recommended:—The paper should be moistened on the back by sponging and blotting off. It should then be pinned on a board, the moist side downwards, so that two of its edges (suppose the right-hand and lower ones) shall project a little beyond those of the board. The board then being inclined twenty or thirty degrees to the horizon, the alcoholic tincture (mixed with a very little water, if the petals themselves be not very juicy) is to be applied with a brush in strokes from left to right,

taking care *not to go* over the edges which rest on the board; but to pass clearly over those that project; and observing also to carry the tint from below upwards by quick sweeping strokes, leaving no dry spaces between them, but keeping up a continuity of wet spaces. When all is wet, cross them by another set of strokes from above downwards, so managing the brush as to leave no floating liquid on the paper. It must then be dried as quickly as possible over a stove, or in a warm current of air, avoiding, however, such· heat as may injure the tint.

In addition to the flowers already mentioned in my third chapter, the following are among those experimented upon and found to give tolerable good photographic sensitives. I can only enumerate them, referring the student, for any further information he may desire on the subject, to Mr. Hunt's work; although what I have said above is sufficient for all practical purposes; and any one, with the ambition, can readily experiment upon them, without further research, on any other flower he may choose.

Viola Odorata—or sweet sented violet, yields to alcohol a rich blue color, which it imparts in high perfection to paper

Senecio Splendens—or double purple groundsel, yields a beautiful color to paper.

The leaves of the laurel, common cabbage, and the grasses, are found sufficiently senstive.

Common Merrigold yields an invaluable fæcula, which appears identical with that produced by the Wall-flower, and Cochorus japonica mentioned before, and is very sensitive, but photographs procured upon it cannot be preserved, the color is so fugitive.

From an examination of the researches of Sir John Herschel on the coloring matter of plants, it will be seen that the action of the sun's rays is to destroy the color, effecting a sort of chromatic analysis, in which two distinct elements of color are separated, by destroying the one and leaving the other outstanding. The action is confined within the visible spectrum, and thus a broad distinction is exhibited between the action of the sun's rays on vegetable juices and on argentine compounds, the latter being most sensibly affected by the invisible rays beyond the violet.

It may also be observed, that the rays effective in destroying a given tint, are in a great many cases, those whose union produces a color complimentary to the tint destroyed, or, at least, one belonging to that class of colors to which such complementary tint may be preferred. For instance, yellows tending towards orange are destroyed with more energy by the blue rays ; blues by the red, orange and yellow rays ; purples and pinks by yellow and green rays.

V. AMPHITYPE.

This process is a discovery of Sir John Herschel and receives its name from the fact that both negative and positive photographs can be produced by one process. The positive pictures obtained by it have a perfect resemblance to impressions of engravings with common printer's ink. The process, although not yet fully carried out, promises to be of vast utility.

Paper proper for producing an amphitype picture may be prepared either with the ferro-tartrate or the ferro-citrate of the protoxide, or the peroxide of mercury, or of the protoxide of lead, by using creams of these salts, or by successive applications of the nitrates of the respec-

tive oxides, singly or in mixture, to the paper, alternating with solutions of the ammonia-tartrate or the ammonia-citrate of iron, the latter solution being last applied, and in more or less excess. I purposely avoid stating proportions, as I have not yet been able to fix upon any which certainly succeed. Paper so prepared and dried takes a negative picture, in a time varying from half an hour to five or six hours, according to the intensity of the light; and the impression produced varies in apparent force from a faint and hardly perceptible picture to one of the highest conceivable fulness and richness both of tint and detail, the color being in this case a superb velvety brown. This extreme richness of effect is not produced unless lead be present, either in the ingredients used, *or in the paper itself.* It is not, as I originally supposed, due to the presence of free tartaric acid. The pictures in this state are not permanent. They fade in the dark, though with very different degrees of rapidity, some (especially if free tartaric or citric acid be present) in a few days, while others remain for weeks unimpaired, and require whole years for their total obliteration. But though entirely faded out in appearance, the picture is only rendered dormant, and may be restored, changing its character from negative to positive, and its colors from brown to black, (in the shadows), by the following process :—A bath being prepared by pouring a small quantity of solution of pernitrate of mercury into a large quantity of water, and letting the subnitrated precipitates subside, the picture may be immersed in it, (carefully and repeatedly clearing off all air bubbles,) and allowed to remain till the picture (if any where visible,) is entirely destroyed ; or if faded, till it is judged sufficient from previous experience ; a term which is often marked

by the appearance of a feeble positive picture, of a bright
yellow hue, on the pale yellow ground of the paper. A
long time (several weeks) is often required for this, but
heat accelerates the action, and it is often completed in a
few hours. In this state the picture is to be very tho-
roughly rinsed and soaked in pure warm water, and then
dried. It is then to be well ironed with a smooth iron,
heated so as barely not to injure the paper, placing it, for
greater security against scorching, between clean smooth
paper. If then the process have been successful, a per-
fectly black positive picture is at once developed. At
first it most commonly happens that the whole picture is
sooty or dingy to such a degree that it is condemned as
spoiled, but on keeping it between the leaves of a book,
especially in a moist atmosphere, by extremely slow de-
grees this dinginess disappears, and the picture disen-
gages itself with continually increasing sharpness and
clearness, and acquires the exact effect of a copper-plate
engraving on a paper more or less tinted with a pale yel-
low.

I ought to observe, that the best and most uniform spe-
cimens which I have procured have been on paper pre-
viously washed with certain preparations of uric acid,
which is a very remarkable and powerful photographic
element. The intensity of the original negative picture
is no criterion of what may be expected in the positive
It is from the production by one and the same action of
light, of either a positive or negative picture according
to the subsequent manipulations, that I have designated
the process, thus generally sketched out, by the term
Amphitype,—a name suggested by Mr. Talbot, to whom
I communicated this singular result; and to this process
or class of processes (which I cannot doubt when pur-

sued will lead to some very beautiful results,) I propose to restrict the name in question, though it applies even more appropriately to the following exceedingly curious and remarkable one, in which silver is concerned :

At the last meeting I announced a mode of producing, by means of a solution of silver, in conjunction with ferro-tartaric acid, a dormant picture brought into a forcible negative impression by the breath or moist air. (*See Cyanotype.*) The solution then described, and which had at that time been prepared some weeks, I may here incidentally remark, has retained its limpidity and photogenic properties, quite unimpaired during the whole year since elapsed, and is now as sensitive as ever,—a property of no small value. Now, when a picture (for example an impression from an engraving) is taken on paper washed with this solution, it shows no sign of a picture on its back, whether that on its face is developed or not ; but if, while the actinic influence is still fresh upon the face, (*i.e.*, as soon as it is removed from the light), *the back* be exposed for a very few seconds to the sunshine, and then removed to a gloomy place, *a positive picture, the exact complement of the negative one on the other side,* though wanting of course in sharpness if the paper be thick, *slowly and gradually makes its appearance* there, and in half an hour or an hour acquires a considerable intensity. I ought to mention that the " ferro-tartaric acid" in question is prepared by precipitating the ferro-tartrate of ammonia (ammonia-tartrate of iron) by acetate of lead, and decomposing the precipitate by dilute sulphuric acid. When lead is used in the preparation of Amphitype paper, the parts upon which the light has acted are found to be in a very high degree *rendered water proof.— Sir J. Herschel.*

This process is a new invention of our countryman,
J. A. Whipple, Esq., of Boston, and has been patented
by M. A. Root, Esq., of Philadelphia. It will be seen,
however, from the previous pages of my work that Mr.
Root is mistaken in regard to his being the first improve-
ment patented in this country, althongh it is unquestion-
ably the first by an American. Of this improvement
Mr. Root says :

VI. " CRAYON DAGUERREOTYPE."

" The improvement to which you refer is denominated
" The Crayon Daguerreotype." This invention made by
Mr. J. A. Whipple, is the only improvement in Daguer-
reotyping, I believe, for which Letters Patent for the
United States were ever issued. The pictures produced
by this process—which is of the simplest description
imaginable—have the appearance and effect of very fine
" Crayon Drawings," from which the improvement takes
its name. Some of our most distinguished artists have
given it their unqualified admiration. Among them, our
Mezzotinto Engravers, especially John Sartain, Esq.,
who, from his rich embellishments to most of the leading
Magazines and Annuals of the country, as well as from
the celebrity of the superb Magazine which bears his
name, is so well known and so well qualified to judge of
its merits. As an auxiliary to the artist, in furnishing
heads to the Magazines, or other works, it is invaluable ;
the great objeçt which it accomplishes being to give a
finer effect and more distinct expression to all the features—
the whole power of the instrument being directed to, and
confined to the head."

" The late hour at which this subject has been brought
to our notice prevents so full a description as we would
otherwise have been glad to furnish. The New England

States have been disposed of ; negotiations for any of the others can be made through M. A. Root, 140 Chestnut street, Philadelphia."

" A series of beautiful portraits are about being pre-pared by the " Crayton Process" for the express purpose of being placed on the exhibition at the " *Art Union*," when amateurs, artists, and the public generally will have an opportunity of witnessing its effect. We are es-pecially gratified with this striking improvement, from the advantages which it promises to the Daguerrean art."

" It is admirably designed to excite a new interest on the subject through the community, and in this way—and from its tendency to render the art more generally useful, and to elevate and distinguish it—to make it to all a mat-ter of more general importance."

" Yours respectfully,

" M. A. Root."

In our second edition, we hope—with Mr. Root's per-mission—to lay the whole process before the public, al-though our artists must bear in mind that Mr. Root's pa-tent secures to him the exclusive right of its application.

CHAP. XI.

Having before noticed the fact that some advances had
been made towards taking Daguerreotypes in color, by
means of solar rays, and expressed the hope that the day
was not far distant when this might be accomplished, I
here subjoin Mr. Hunt's remarks on this subject.

Mr. Biot, in 1840, speaking of Mr. Fox Talbot's
beautiful calotype pictures, considers as an illusion "the
hope to reconcile, not only the intensity but the tints of
the chemical impressions produced by radiations, with
the colors of the object from which these radiations ema-
nated." It is true that three years have passed away, and
we have not yet produced colored images; yet I am not
inclined to consider the hope as entirely illusive.

It must be remembered that the color of bodies de-
pends entirely upon the arrangement of their molecules.
We have numerous very beautiful experiments in proof of
this. The bi-niodide of mercury is a fine scarlet when
precipitated. If this precipitate is heated between plates
of glass, it is converted into crystals of a fine sulphur
yellow, which remain of that color if undisturbed, but
which becomes very speedily scarlet if touched with any
pointed instrument. This very curious optical phenome-

na has been investigated by Mr. Talbot and by Mr. War-
rington. Perfectly dry sulphate of copper is white ; the
slightest moisture turns it blue. Muriate of cobalt is of
a pale pink color; a very slight heat, by removing a lit-
tle moisture, changes it to a green. These are a few in-
stances selected from many which might be given.

If we receive a prismatic spectrum on some papers, we
have evidence that the molecular or chemical disturbance
bears some relation to the color of each ray, or, in other
words, that colored light so modifies the action of ENER-
GIA that the impression it makes is in proportion to the
color of the light it accompanies, and hence there results
a molecular arrangement capable of reflecting colors dif-
ferently. Some instances have been given in which the
rays impressed correspond with the colors of the lumin-
ous rays in a very remarkable manner.* One of the most
decided cases is that of the paper prepared with the fluo-
ride of soda and nitrate of silver. Sir John Herschel
was, however, the first to obtain any good specimens of
photographically impressed prismatic colorations.

It was noticed by Daguerre that a red house gave a
reddish image on his iodized silver plate in the camera
obscura ; and Mr. Talbot observed, very early in his re-
searches, that the red of a colored print was copied of a
red color, on paper spread with the chloride of silver.‡

" In 1840 I communicated to Sir John Herschel some
very curious results obtained by the use of colored me-
dia, which he did me the honor of publishing in one of

* See Mr. Hunt's " Researches on Light."

‡ In 1842, I had shown me a picture of a house in the Bowery, which had
been repaired a few days previous, and in the wall a red brick left. This
brick was brought out on the Daguerreotype plate of precisely the same color
as the brick itself. The same artist also exhibited to me, the full length por-
trait of a gentleman who wore a pair of pantaloons having a blue striped
figure. This blue stripe was fully brought out, of the same color, in the pic-
ture.—AMER. ED.

his memoirs on the subject from which I again copy it."

"A paper prepared with muriate of barytes and nitrate of silver, allowed to darken whilst wet in the sunshine to a chocolate color, was placed under a frame containing a red, a yellow, a green, and a blue glass. After a week's exposure to diffused light, it became red under the red glass, a dirty yellow under the yellow glass, a dark green under the green, and a light olive under the blue.

"The above paper washed with a solution of salt of iodine, is very sensitive to light, and gives a beautiful picture. A picture thus taken was placed beneath the above glasses, and another beneath four flat bottles containing colored fluids. In a few days, under the red glass and fluid, the picture became a dark blue, under the yellow a light blue, under the green it remained unchanged, whilst under the blue it became a rose red, which in about three weeks changed into green. Many other experiments of a similar nature have been tried since that time with like results.

"In the summer of 1843, when engaged in some experiments on papers prepared according to the principles of Mr. Talbot's calotype, I had placed in a camera obscura a paper prepared with the bromide of silver and gallic acid. The camera embraced a picture of a clear blue sky, stucco-fronted houses, and a green field. The paper was unavoidably exposed for a longer period than was intended—about fifteen minutes,—a very beautiful picture was impressed, which, when held between the eye and the light, exhibited a curious order of colors. The sky was of a crimson hue, the houses of a slaty blue, and the green fields of a brick red tint. Surely these results appear to encourage the hope, that we may even-

tually arrive at a process by which external nature may be made to impress its images on prepared surfaces, in all the beauty of their native coloration."

PHOTOGRAPHIC DEVIATIONS.

Before taking leave of the subject of photogenic drawing, I must mention one or two facts, which may be of essential service to operators.

It has been observed by Daguerre, and others, in Europe, and probably by some of our own artists, that the sun two hours after it has passed the meridian, is much less effective in the photographic process, than it is two hours previous to its having reached that point. This may depend upon an absorptive power of the air, which may reasonably be supposed to be more charged with vapor two hours before noon. The fuse of the hygrometer may possibly establish the truth or falsity of this supposition. The fact, however, of a better result being produced before noon being established, persons wishing their portraits taken, will see the advantage of obtaining an early sitting, if they wish good pictures. On the other hand, if the supposition above mentioned prove true, a too early sitting must be avoided.

If we take a considerable thickness of a dense purple fluid, as, for instance, a solution of the ammonia-sulphate of copper, we shall find that the quantity of light is considerably diminished, at least four-fifths of the luminous rays being absorbed, while the chemical rays permeate it with the greatest facility, and sensitive preparations are affected by its influence, notwithstanding the deficiency of light, nearly as powerfully as if exposed to the undecomposed sunbeams.

It was first imagined that " under the brilliant sun and clear skies of the south, photographic pictures would

be produced with much greater quickness than they could be in the atmosphere of Paris. It is found, however, that a much longer time is required. Even in the clear and beautiful light of the higher Alps, it has been proved that the production of the photographic picture requires many minutes more, even with the most sensitive preparations, than it does in London. It has also been found that under the brilliant light of Mexico, twenty minutes, and half an hour, are required to produce effects which in England would occupy but a minute; and travellers engaged in copying the antiquities of Yucatan have on several occasions abandoned the use of the photographic camera, and taken to their sketch books. Dr. Draper* has observed a similar difference between the chemical action of light in New York and Virginia. This can be only explained by the supposition that the intensity of the light and heat of these climes interferes with the action of the ENERGIC rays on those sensitive preparations which are employed.

LUNAR PICTURES—DRUMMOND LIGHT.

The Roman Astronomers state that they have procured Daguerreotype impressions of the Nebula of the sword of Orion. Signor Rondini has a secret method of receiving photographic images on lithographic stone; on such a prepared stone they have succeeded in impressing an image of the Nebula and its stars; " and from that stone they have been enabled to take impressions on paper, unlimited in number, of singular beauty, and of perfect precision." Experiments have, however, proved that " no heating power exists in the moon's rays, and that lunar light will not act chemically upon the iduret of silver."

* I would here take occasion to remark that our countryman, Dr. Draper, is very frequently quoted by Mr, Huut in his " Researches."

It was at one time supposed that terrestrial or artificial light possessed no chemical rays, but this is incorrect— Mr. Brande discovered that although the concentrated light of the moon, or the light even of olefiant gas, however intense, had no effect on chloride of silver, or on a mixture of chloride and hydrogen, yet the light emitted by electerized charcoal blackens the salt. At the Royal Polytechnic Institution pictures have been taken by means of sensitive paper acted upon by the Drummond Light; but it must of course be distinctly understood, that they are inferior to those taken by the light of the sun, or diffused daylight.

If our operators could manage to produce good pictures in this way they would put money in their pockets, as many who cannot find time during the day would resort to their rooms at night. I throw out the hint in hopes some one will make the experiment.

I have learned, since the above was written, that an operator in Boston succeeded a short time since in procuring very good pictures by the aid of the Drummond Light; but that the intensity of the light falling directly upon the sitter's face caused great difficulty, and he abandoned it. This may, probably, be remedied by interposing a screen of very thin tissue paper tinged slightly of a bluish color.

CHAP. XII.

Nearly, if not quite all the various colors used in painting may be made from the five primitive colors, black, white, blue, red and yellow, but for the Daguerrean artist it would be the best policy to obtain such as are required by their art already prepared. In a majority of cases, the following will be found sufficient, viz.

Carmine.

Prussian Blue.

White.

Chrome Yellow, Gamboge, Yellow Ochre; or all three.*

Light Red.

Indigo.

Burnt Sienna.

Bistre, or Burnt Umber.

If, in coloring any part of a lady's or gentleman's apparel, it is found necessary to produce other tints and shades, the following combinations may be used:

Orange—Mix yellow with red, making it darker or lighter by using more or less red.

Purple—This is made with Prussian blue, or indigo and red. Carmine and Prussian blue producing the

* Gamboge is best for drapery ; Ochre for the face.

richest color, which may be deepened in the shadows by a slight addition of indigo or brown.

Greens—Prussian blue and gamboge makes a very fine green, which may be varied to suit the taste of the sitter or operator, by larger portions of either, or by adding white, burnt sienna, indigo, and red, as the case may require. These combinations, under different modifications, give almost endless varieties of green.

Brown—May be made of different shades of umber, carmine and lamp-black.

Neutral tint—Is composed of indigo and lamp-black.

Crimson—Mix carmine and white, deepening the shaded parts of the picture with additional carmine.

Flesh Color—The best representative of flesh color is light red, brightened in the more glowing or warmer parts, with carmine, softened off in the lighter portions with white, and shaded with purple and burnt sienna.

Lead Color—Mix indigo and white in proportions to suit.

Scarlet—Carmine and light red.

For Jewelry cups of gold and silver preparations accompany each box for Daguerreotypists, or may be procured separately.

The method of laying colors on Daguerreotypes is one of considerable difficulty, inasmuch as they are used in the form of perfectly dry impalpable powder. The author of this little work is now experimenting, in order, if possible, to discover some more easy, artistic and unexceptionable method. If successful, the result will be published in a future edition.

The rules we shall give for coloring Daguerreotypes depends, and are founded, upon those observed in miniature painting, and are intended more as hints to Da-

guerrean artists, in hopes of leading them to attempt im-
provements, than as instructions wholly to be observed.

The writer is confident that some compound or ingre-
dient may yet be discovered which, when mixed with the
colors, will give a more delicate, pleasing, and natural
appearance to the picture than is derived from the pre-
sent mode of laying them on, which in his estimation is
more like plastering than coloring.

In Coloring Daguerreotypes, the principal shades
of the head are to be made with bistre, mixed with
burnt sienna, touching some places with a mixture of
carmine and indigo. The flesh tints are produced by the
use of light red, deepened towards the shaded parts with
yellow ochre, blue and carmine mixed with indigo, while
the warmer, or more highly colored parts have a slight
excess of carmine or lake. Color the shades about the
mouth and neck with yellow ochre, blue, and a very
little carmine, heightening the color of the lips with car-
mine and light red, letting the light red predominate on
the upper, and the carmine on the lower lip ; the shades
in the corner of the mouth being touched slightly with
burnt sienna, mixed with carmine.

In coloring the eyes, the artist will of course be guided
by nature, observing a very delicate touch in laying on
the colors, so as to preserve as much transparency as
possible. A slight touch of blue—ultramarine would be
best if it would adhere to the Daguerreotype plate—in
the whites of the eye near the iris, will produce a good
effect.

In coloring the heads of men it will be necessary to
use the darker tints with more freedom, according to the
complexion of the sitter. For women, the warmer tints
should predominate, and in order to give that transpa-

rency so universal with the softer sex—and which gives
so much loveliness and beauty to the face—a little white
may be judiciously intermingled with the red tints about
the lighter portions of the face.

In taking a picture of a lady with light or auburn hair,
by the Daguerrean process, much of the beauty of the
face is destroyed, on account of the imperfect manner in
which light conveys the image of light objects to the
spectrum of the camera. This may be obviated in some
measure by proper coloring. To do this, touch the
shaded parts with burnt sienna and bistre, filling up the
lighter portions with yellow ochre, delicate touches of
burnt sienna, and in those parts which naturally have a
bluish tint, add *very* delicate touches of purple—so de-
licate in fact as hardly to be perceived. The roots of the
hair at the forehead should also be touched with blue,
and the eyebrows near the temples made of a pinkish
tint.

The chin of a woman is nearly of the same color as
the cheeks in the most glowing parts. In men it is
stronger, and of a bluish tint, in order to produce the
effect given by the beard.

In portraits of women—the middle tints on the side of
the light, which are perceived on the bosom and arms,
are made of a slight mixture of ochre, blue and lake, (or
carmine), to which add, on the shaded sides, ochre, bis-
tre and purple, the latter in the darker parts. The tints
of the hands should be the same as the other parts of the
flesh, the ends of the fingers being a little pinkish and
the nails of a violet hue. If any portion of the fleshy
parts is shaded by portions of the dress, or by the posi-
tion of the hand, this shade should be colored with um-
ber mixed with purple.

To Color the Drapery.—*Violet Velvet*—Use purple made of Prussian blue and carmine, touching up the shaded parts with indigo blue.

Green Velvet—Mix Prussian blue and red-orpiment, shade with purple, and touch up the lights with a little white.

Red Velvet—Mix a very little brown with carmine, shading with purple, marking the lights in the strongest parts with *pure* carmine, and touch the most brilliant slightly with white.

White Feathers—May be improved by delicately touching the shaded parts with a little blue mixed with white. *White* muslin, linen, lace, satin, silk, etc., may also be colored in the same way, being careful not to lay the color on too heavily.

Furs—*Red Furs* may be imitated by using light red and a little masticot, shaded with umber. *Gray Furs*—black and white mixed and shaded with bistre. *Sable*—white shaded lightly with yellow ochre.

These few directions are quite sufficient for the art, and it is quite unnecessary for me to pursue the subject further. I would, however, remark that the Daguerreotypists would find it greatly to their advantage to visit the studies of our best artists, our public galleries of paintings, and statuary, and wherever else they can obtain a sight of fine paintings, and study the various styles of coloring, atitudes, folds of drapery and other points of the art. In coloring Daguerreotypes, artists will find the magnifying glass of much advantage in detecting any imperfections in the plate or in the image, which may be remedied by the brush. In selecting brushes choose those most susceptible of a fine point, which may be escertained by wetting them between the lips, or in a glass of water.

CHAP. XIII.

The last number (for March, 1849) of the " London Art-Journal, gives the following description of a recent improvement in Photographic Manipulation, and as I am desirous of furnishing everything new in the art, I stop the press to add it, entire, to my work.

" Since the photographic power of the solar rays bears no direct relation to their luminous influence, it becomes a question of considerable importance to those who practice the beautiful art of photography, to have the means of readily measuring the ever changing activity of this force. Several plans more or less successful, have been devised by Sir John Herschel, Messrs. Jordan, Shaw and Hunt. The instrument, however, which is now brought forward by Mr. Claudet, who is well known as one of our most successful Daguerreotypists, appears admirably suited to all those purposes which the practical man requires. The great difficulty which continually annoys the photographic amateur and artist, is the determination of the sensibility of each tablet employed, relatively to the amount of radiation, luminous and chemical, with which he is working. With the photographometer of Mr. Claudet this is easily ascer-

tained. The following woodcuts and concise description
will sufficiently indicate this useful and simple apparatus.

Fig. 30.

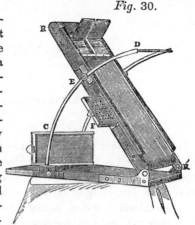

" For an instru-
ment of this kind it
is important in the
first place to have a
motion always uni-
form, without com-
plicated or expen-
sive mechanism.—
This is obtained by
means founded upon
the principle of the
fall of bodies sliding
down an inclined
plane. The sensi-
tive surface is ex-
posed to the light by the rapid and uniform passage of a
metal plate, A, B, (*Fig.* 31,) having openings of different
length, which follow a geometric progression. It is evi-
dent that the exposure to light will be the same for each
experiment, because the plate furnished with the propor-
tional openings falls always with the same rapidity, the
height of the fall being constant, and the angle of the
inclined plane the same. Each opening of this moveable
plate allows the light to pass during the same space of
time, and the effect upon the sensitive surface indicates
exactly the intensity of the chemical rays. The rapidity
of the fall may be augmented or diminished by altering
the inclination of the plane by means of a graduated arc,
C, D, (*Fig.* 30,) furnished with a screw, E, by which it
may be fixed at any angle. The same result may be ob-
tained by modifying the height of the fall or the weight

of the moveable plate. The photogenic surface, whether

Fig. 31.

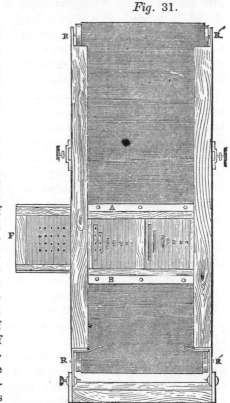

it be the Daguerreotype plate, the Talbotype paper, or any other preparation sensitive to light, is placed near the bottom of the inclined plane, F. It is covered by a thin plate of metal, pierced with circular holes, which correspond to the openings of the moveable plate at the moment of the passage of the latter, during which the sensitive surface receives the light wherever the circular holes leave it exposed.

" The part of the apparatus which contains the sensitive surface is an independent frame. and it slides from a dark box into an opening on the side of the inclined plane.

" A covering of black cloth impermeable to light is, attached to the sides of the moveable plate, enveloping the whole inclined plane, rolling freely over two rollers, R, R, placed the one at the upper and the other at the lower part of the inclined plane. This cloth prevents the light striking the sensitive surface before and after the passage of the moveable plate.

" It will be seen that this apparatus enables the experimentalist to ascertain with great precision the exact length of time which is required to produce a given amount of actinic change upon any sensitive photographic surface, whether on metal or paper. Although at present some calculation is necessary to determine the difference between the time which is necessary for exposure in direct radiation, and to the action of the secondary radiations of the camera obscura ; this is, however, a very simple matter, and it appears to us exceedingly easy to adapt an instrument of this description to the camera itself.

" By this instrument Mr. Claudet has already determined many very important points. Among others, he has proved that on the most sensitive Daguerreotype plate an exposure of .0001 part of a second is sufficient to produce a decided effect.

" Regarding photography as an auxiliary aid to the artist of no mean value, we are pleased to record a description of an instrument which, without being complicated, promises to be exceedingly useful. In this opinion we are not singular; at a recent meeting of the Photographic Club, to which this instrument was exhibited, it was with much real satisfaction that we learned that several of our most eminent artists were now eager and most successful students in Photography. The

beautiful productions of the more prominent members of this club excited the admiration of all, particularly the copies of architectural beauties, and small bits of landscape, by Messrs. Cundell and Owen. We think that now the artist sees the advantage he may derive from the aid of science, that both will gain by the union."

I hope the above description will induce our townsman, Mr. Roach, to successfully produce an instrument that will meet the wants of our artists in that part of the Daguerrean process referred to.

FINIS.

INDEX.